IMAGES
of America

LOOKOUT
MOUNTAIN

IMAGES
of America

LOOKOUT
MOUNTAIN

William F. Hull

ARCADIA
PUBLISHING

Published by Arcadia Publishing
Charleston SC, Chicago IL, Portsmouth NH, San Francisco CA

Printed in the United States of America

Library of Congress Control Number: 2009929788

For all general information contact Arcadia Publishing at:
Telephone 843-853-2070
Fax 843-853-0044
E-mail sales@arcadiapublishing.com
For customer service and orders:
Toll-Free 1-888-313-2665

Visit us on the Internet at www.arcadiapublishing.com

(

For Eleanor, Andrew, and David.

CONTENTS

ACKNOWLEDGMENTS

The author wishes to thank the superior staff at the local history and genealogy desk at the downtown Chattanooga–Hamilton County Bicentennial Public Library. Their attitude is outstanding and their knowledge broad. A note of gratitude is extended to librarian Jim Reece for his work and patience. Acknowledgment must be made to Mrs. Earl A. Millwood (Minette), daughter of the late Paul Heiner; Chattanooga's history would be much diminished without his contribution. I would also like to recognize John Wilson's publication *Scenic, Historic Lookout Mountain* for clarification on several points. Special thanks are also due to John C. and Thelonious M. for their inspiration.

Unless otherwise noted, all images are courtesy of the Chattanooga–Hamilton County Bicentennial Public Library.

INTRODUCTION

What makes a landmark? Why would Martin Luther King in his famous "I Have a Dream" speech ask that "freedom ring from Lookout Mountain of Tennessee?" Was it because of its intriguing profile or unique features? Its unusual history? Its reputation or some remarkable action? Or perhaps it is a simple, unchanging presence. All of these attributes are characteristic of Lookout Mountain, Tennessee. A long plateau with the forward tip resting 3 miles inside the state of Tennessee, its broadening spine continues for 80 more miles in a southerly direction through northwest Georgia and into east central Alabama, finally diminishing near Gadsden, Alabama. Thanks to a fairly accurate (though recently contested) survey done in 1818, the nose of the mountain rests in Tennessee, overlooking the town of Chattanooga. The brow faces the great swoop of Moccasin Bend, a huge turn in the Tennessee River as it flows downstream from the mountains of North Carolina and east Tennessee to the south, rolling through an impressive gorge known as the Grand Canyon of the Tennessee.

Lookout Mountain is geologically an old mountain. Essentially a plateau, it is a part of the southern Appalachians that was lifted up from an ancient sea and has been worn down from millions of years of erosion. On the surface is a layer of sandstone that is resting on a belt of shale. It is the erosion of this sandstone cap that gives the area's mountains their distinctive stone bluffs, or palisades that run around the upper edges above the forested slopes. Underneath these two layers is a deep course of limestone, full of underground passages that geologists believe connect serpentinely to cave systems miles and miles away. Human habitation on and around the mountain has been intermittent for thousands of years. The Great Indian Warpath meandered over the talus of the mountain. The Cherokee Nation lived in small settlements like Lookout Town and Nickajack up and down the waterways in the valley; the Creek (Muscogee) Indians lived farther down the mountain in towns nearer to present-day Gadsden. This countryside was known as the Cherokee Nation in the 1600s and 1700s, and with the exception of fighting in 1782 between Tennessean John Sevier and a faction of the Cherokees known as the Chickamaugas, life was relatively constant.

By the 1790s, a Cherokee man named Daniel Ross was working his farmstead and tannery at Chattanooga Creek in the shadow of Lookout Mountain. His son, John Ross, one of the outstanding Americans of the 19th century, would become the "founder" of Chattanooga in 1816 when he built a warehouse on the landing that would become the present downtown. It was John Ross, principal chief of the Cherokee Nation, who fought to keep his tribe's homeland from the ever-encroaching United States and the avaricious settlers that would drive them west on the Trail of Tears in 1838.

Before the War Between the States, Lookout Mountain was primarily a place for exploration, but by the fall of 1863, Chattanooga was the center of a major conflict. For one day—on November

24—Lookout Mountain was the focus of the fighting when Union forces valiantly trying to pry themselves free from the Confederate siege would mass on the western foot and sweep up the slopes of the mountain. Known as the Battle above the Clouds, the Union victory drove the Confederates back toward Georgia and would eventually lead to the March to the Sea and the defeat of Dixie. After the war, numerous Union soldiers returned to Chattanooga to create an industrial future for the town. Still with only one rutted road up the mountain, Lookout for the most part remained the province of Col. James A. Whiteside, a major landowner who also owned the toll pike. However, a deadly yellow fever epidemic that spread through Chattanooga in 1878 frightened hundreds of people out of town and up the mountain to what they considered a safer and healthier haven. As a result, the upper environs became more familiar to the local citizenry. By the late 1880s, a building boom was taking place in town and a rail line was laid up the mountain to a hotel at the Point. Here one could take in the magnificent panorama of the river valley below. The emerging prosperity engendered another rail line, which still exists today, and some permanent homes in what was becoming known as Summertown. By 1900, some well-to-do citizens were establishing finely finished homes and began taking up residence year-round.

During this time, the fading generation that fought the Civil War was moving toward reconciliation with their former enemies, and these veterans proposed the building of a park on the heights to commemorate the struggle that took place. In 1905, the Point Park entrance was completed, and the nearby Cravens House, scene of the turning point in that battle, was opened. A reverent public came to pay their respects at this site and the larger memorial in the Georgia valley below known as the Chickamauga and Chattanooga National Military Park. In time, the Dixie Highway—a long, paved national highway—became a reality and swung over the foot of the mountain along the path of the old Wauhatchie Pike, bringing a new breed of American travelers—tourists, hungry for novel sights and a rest stop. On the mountain above, an entrepreneurial husband and wife, Garnet and Freida Carter, took a wild assortment of strangely beautiful and intriguing stone formations and created a large rock garden with looping paths, plantings, small cast-iron creatures, and a stunning view that was called Rock City. Augmented by signs painted on barns around the Southland, a major American roadside attraction came to life. At one point during a project, Carter fashioned a small replica golf course out of found materials, unwittingly creating "Tom Thumb" or miniature golf as it came to be known. Both entities were a solid success. Within a few years, another local natural phenomenon, Ruby Falls, would spring to life in the form of a beautiful waterfall inside the mountain rock. Discovered by Leo Lambert and named for his wife, the commercialized cave would draw thousands of people a year and inundate this wealthy mountain community with tour buses full of visitors in the warmer months.

Over time, Lookout Mountain would deservedly gain the reputation of the power center of Chattanooga—and with more than a little truth. Two of its residents in modern times, Estes Kefauver and Bill Brock, have become U.S. senators. Adolph Ochs, the owner and publisher of the *New York Times*, was one of the great citizens of the city. Famous figures from Babe Ruth to Winston Churchill have made it a point to visit the mountaintop, and numerous industrialists who called the mountain home have done exceedingly well with their various enterprises. With a high per capita income and some impressive family pedigrees, "the mountain" is highly regarded by fund-raisers and politicians alike. Nevertheless, it must be stated that the record of philanthropy by the residents is impressive. Whether through gifts of public land or major donations for worthy projects, the citizens of this tight-knit community have been at the forefront of numerous key projects for this city for a century. Both civic responsibility and entrepreneurial achievement are part of this singular community, and whether one lives in Chattanooga or one simply comes to "see Rock City," the mark of the land that is Lookout Mountain endures.

One

A Southern Landmark in Old America

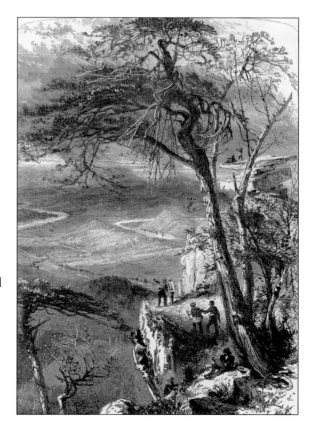

What was astounding for many
early climbers was the view that
was available from the point of the
promontory as one looked north toward
Walden Ridge. Below was the sinuous
curve of Moccasin Bend; to the west
was Raccoon Mountain; and to the
east was the city of Chattanooga and
the mighty Tennessee River coming
in from the north. Breathtaking and
beautiful, it was considered one of
America's stunning panoramas and
provided fair respite to the soul.

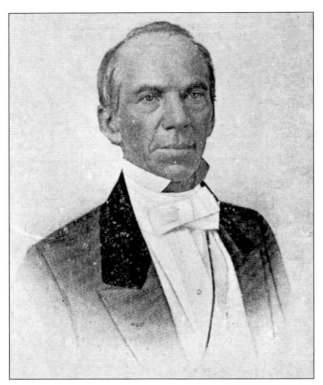

Without a doubt, the first person to make his mark on Lookout Mountain was Col. James Whiteside. Elected to the state legislature at the age of 24, he moved his family to Chattanooga as soon as the Cherokee Nation was marched to Oklahoma on the Trail of Tears. Quickly establishing himself as a man of property, he invested in the railroads and carved a road up Lookout Mountain in 1852 after the Western and Atlantic Railroad arrived in Chattanooga. After buying large parcels of land on the mountain, he built a home and the Lookout Mountain Hotel.

When her husband, James, died in 1861, Harriet Whiteside became a fiercely active entrepreneur in the management of her properties. She owned the Point, with its stunning view, and at one point after the war hired armed guards to make sure that visitors to the summit paid for the visit. Similarly she fought the opening of the first rail line up the mountainside in 1887 near her property since it hurt not only her sightseeing business but reduced the fares she collected from the Whiteside Turnpike. Subsequently Mrs. Whiteside supported the building of the second (and present) incline that was started 10 year later in order to quash the first. Her efforts were a success.

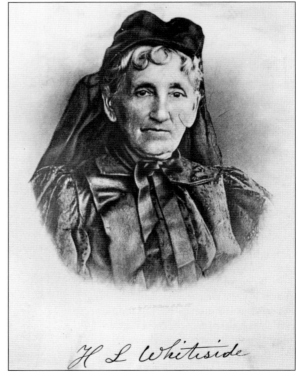

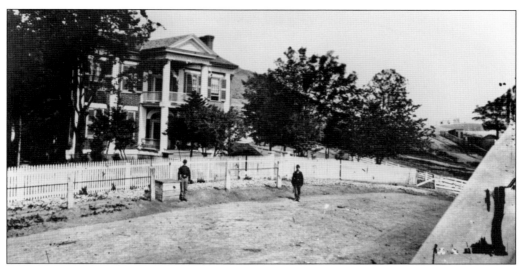

In the city of Chattanooga, the Whitesides were newly minted bluebloods, and this mansion is a testament to their wealth. When the Federal army took over the city, their princely house was used for Union purposes as the guards in this Civil War–era photograph indicate. At that juncture, Harriet Whiteside was given only a short time to leave her property, even after having sworn allegiance to the United States. She was subsequently removed from Chattanooga and imprisoned in the North. After the war, Mrs. Whiteside returned and petitioned the U.S. government for restitution of damage and theft by the "dastardly Yankees." She was successful in her redress and regained much of her wealth.

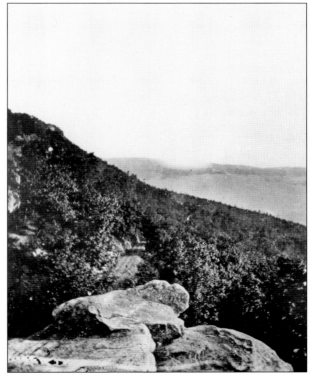

Looking over the rock and down into the densely wooded forest, the viewer may notice a cut through the trees and a wide trail going slowly up the mountain. This is most likely the Whiteside Turnpike, the first major road up the mountainside; the buggy ride could take three to four hours, and a fare would have been collected by a gatekeeper near the top for travel on this early roadway.

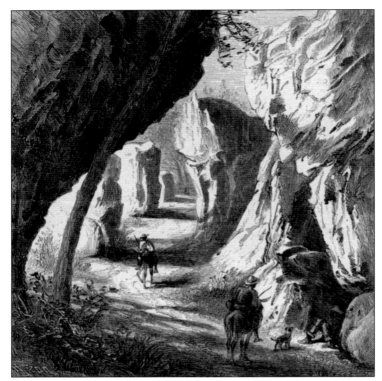

This early pen-and-ink drawing depicts two men and a dog wandering through a landscape of large, curiously shaped rocks. Word of these formations had preceded explorers and most visitors to the mountain. As early as 1823, Daniel Butrick, a missionary to the Cherokee Indians in the area, had ridden up the slopes and written about the enchanting boulders that seemed to be preternaturally assembled into avenues among "a citadel of rocks."

A drawing from *Bryant's Picturesque America* journal shows another view of some huge stones in the midst of a fairly mature forest. The American public was quite interested in what was once known as the old Southwest Territory with its remote and magical qualities. Though curious souls would visit here often, it would be 60 years after the Civil War until one family would get the idea to build an inn among these formations and give the name Rock City to the development of this property.

Once Col. James A. Whiteside had built his turnpike up the mountain in 1852, he erected the Lookout Mountain Hotel in 1857 under the supervision of the builder, Eli Crabtree. Situated near the intersection of Sunset Road and the East Brow Road, this area garnered the name Summertown because it was frequented mostly in the warmer months to escape the relentless humidity of July and August in the valley below. The hotel was fed by spring water and included a smattering of cottages on the grounds. Occupied by both armies during the Civil War, it burned to the ground during that time.

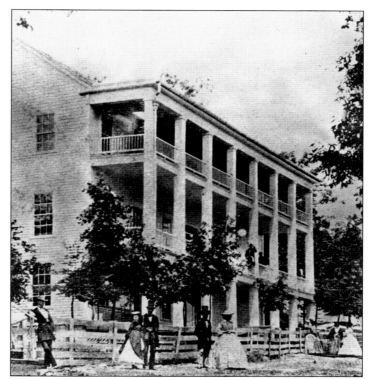

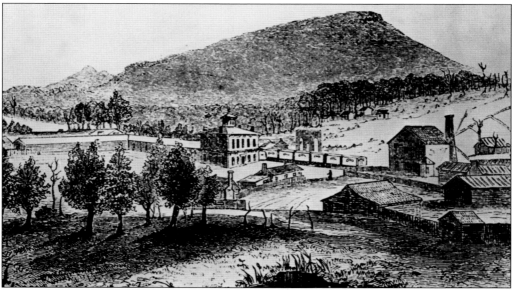

This drawing printed in *Harper's Magazine* in 1858 gives a good idea of both the visual prominence of Lookout Mountain and the rough-hewn nature of Chattanooga at this time. Illustrating the present-day location of Market Street and Martin Luther King Drive, the latter barely a trail at the time, this westward view shows the depot of the Western and Atlantic rail line from Atlanta, which terminated in Chattanooga, and the few buildings around that site. Col. James Whiteside was instrumental in bringing this first railhead to Chattanooga.

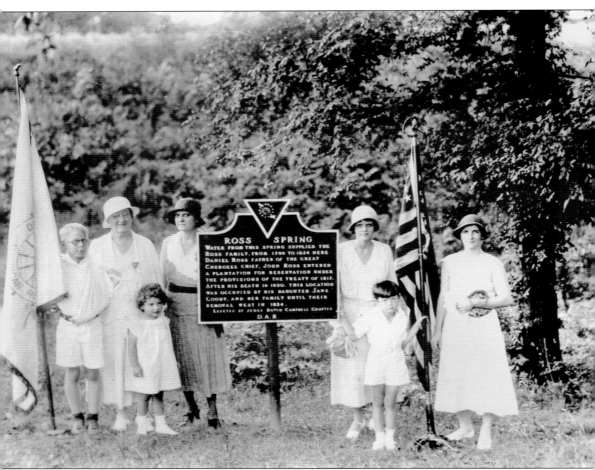

ROSS SPRING
WATER FROM THIS SPRING SUPPLIED THE
ROSS FAMILY, FROM 1799 TO 1834 HERE
DANIEL ROSS FATHER OF THE GREAT
CHEROKEE CHIEF, JOHN ROSS ENTERED
A PLANTATION FOR RESERVATION UNDER
THE PROVISIONS OF THE TREATY OF 1817,
AFTER HIS DEATH IN 1830, THIS LOCATION
WAS OCCUPIED BY HIS DAUGHTER JANE
COODY, AND HER FAMILY UNTIL THEIR
REMOVAL WEST IN 1834.
ERECTED BY JUDGE DAVID CAMPBELL CHAPTER
D.A.R

The founder of Chattanooga is generally considered to be the Cherokee principal chief John Ross, who around 1816 established a small store and warehouse on the site of Ross's Landing, present-day site of the Tennessee Aquarium. His father, Daniel Ross, was well established in the Chattanooga country in the late 1700s and had a farmstead at the foot of Lookout Mountain near the point where Chattanooga Creek enters the Tennessee River. This marker placed by the Daughters of the American Revolution in 1922 commemorates his work and life at that spring.

Two

War Comes to Tennessee

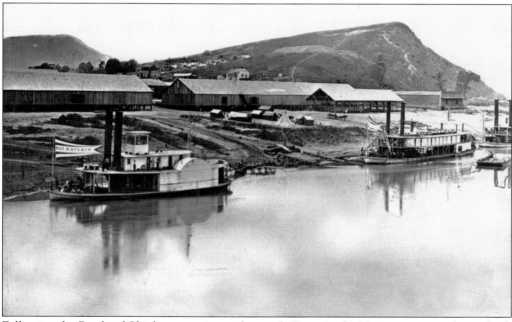

Following the Battle of Chickamauga in nearby north Georgia, the Union army was driven back into Chattanooga and surrounded by the Confederate forces. Besieged in Chattanooga, the Federal troops would eventually welcome steamboats like the *Wauhatchie*, the *Missionary*, and the *Lookout*, seen here at Ross's Landing with food and supplies. In the distance stands Lookout Mountain, where rebel gunners atop the heights made travel on the river treacherous by constant shelling, thereby keeping supplies out of Chattanooga and the siege of the Union troops intact.

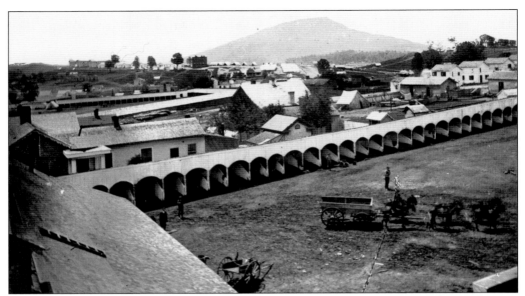

Downtown Chattanooga resembled something of a frontier town in appearance before the U.S. Army arrived and set up shop. With Lookout Mountain in the background, the U.S. Army and its slew of engineers converted it into a working army supply base. Not far from the dock at Ross's Landing, approximately near Fourth and Broad Streets, stood a large corral of army animals. A number of these died during the siege, and according to some accounts, others became food for the troops as rations grew exceedingly thin.

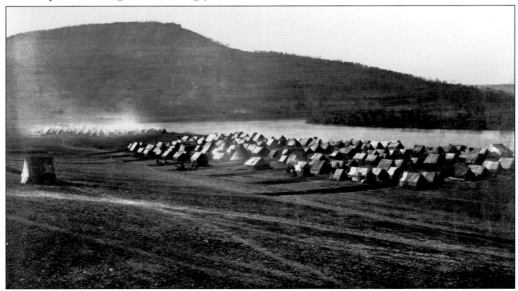

This view of the Federal encampment by the Tennessee River shows a phalanx of bivouacked troops with Lookout Mountain squarely in the background. Near this site, which was south of town, the Union forces built a rolling mill for the manufacture of goods to supply the war effort in Georgia. As a result, after the war, heavy industry developed and thrived on this part of the river for 140 years. The demise of the U.S. Pipe foundry and the Wheland factory in recent years has significantly diminished that site's historic legacy in Chattanooga.

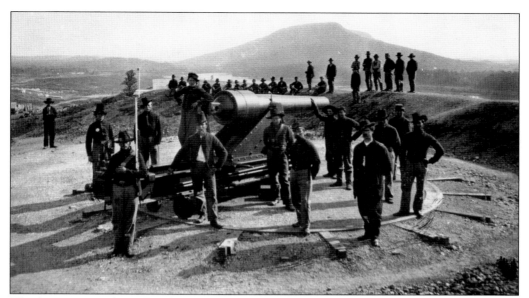

The distinctive outline of Lookout Mountain stands as a backdrop to this cannon emplacement on Cameron Hill. Known as Battery Coolidge, it stood on Cameron Hill where the newly built Blue Cross Blue Shield Company complex stands today. The height of the artillery position at the turn of the river by the city gave the Union a deadly command over this section of the Tennessee River. The mountain in this southwest-looking photograph is about 5 miles distance from the camera.

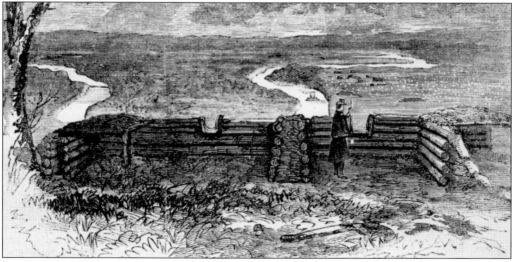

Harper's Weekly was a widely read journal in the 19th century featuring many drawings of news events that served as a kind of predecessor to modern photojournalism. Theodore Davis worked for the publication and traveled to Chattanooga with the Federal troops to draw what he witnessed. Herewith is a sketch of the abandoned "Rebel Battery on Lookout Mountain" depicting the wall of logs behind which the artillery was stationed. Though it was effective at firing at slow-moving objects like vessels on the Tennessee River, during the actual encounter on the mountain—known as the Battle above the Clouds—much of the artillery ended up sailing over the heads of the advancing troops as they crept toward the top.

Below the western side of the mountain is Lookout Valley, which itself is flanked on the west by Sand Mountain. This view from that valley was taken about 1895 and essentially resembles the topography that Gen. Joseph Hooker and company encountered as they approached their objective. Pictured is the railroad track line that was the Nashville, Chattanooga, and St. Louis. Bringing the railroad line in from the west to Chattanooga in the 1850s was no easy feat since it had to skirt the mountain right next to the river as it approached Chattanooga.

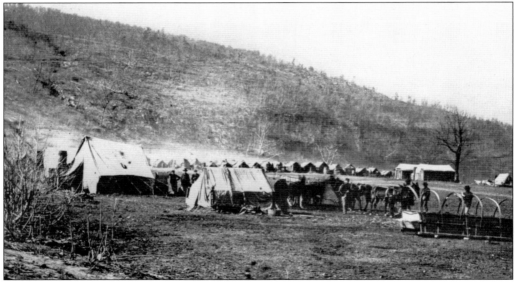

Federal forces under Gen. Joseph Hooker moved into this area next to the west side of the mountain preparing for the attack on Lookout. Under the command of Gen. Ulysses S. Grant, a coordinated plan of attack was readied in November 1863, with the first wave aimed at establishing a position on the slopes before driving the Rebels from the brow of the mountain. Once taken, the rebels would be off the high point that commanded the Tennessee River. Hooker, something of a maverick, surprised his commanding officer by giving orders to advance without Grant's explicit directive.

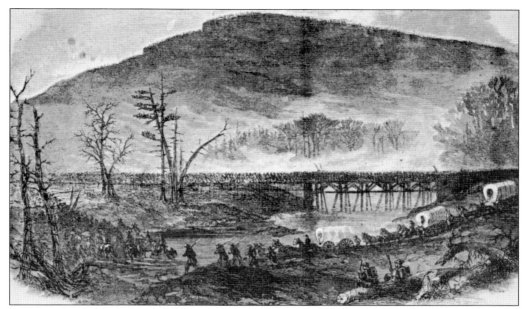

Lookout Creek is a wide, muddy creek that runs along the western flank of Lookout Mountain. As this sketch illustrates, thousands of Union soldiers attached to Gen. John W. Geary crossed this water as the assault up the heavily wooded slopes of the mountain began on the morning of November 24, 1863. In 2006, a total of 145 acres of land in the valley was deeded over to the Chickamauga and Chattanooga National Military Park to preserve the land where much of the action took place.

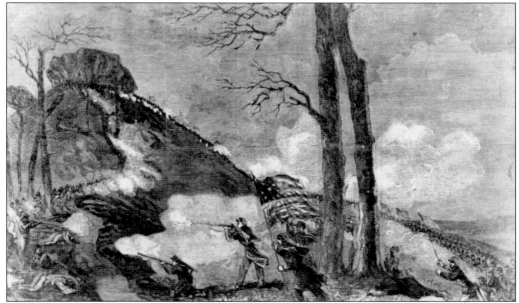

Hooker's column had no easy task going up a 1,300-foot slope into the fire of Confederate sharpshooters. However, large boulders, dense forest, and a developing fog actually worked to the Yankees' advantage, making it difficult for the Southerners to get a clear shot and giving the advancing Federals cover from the artillery and musket fire directed at them.

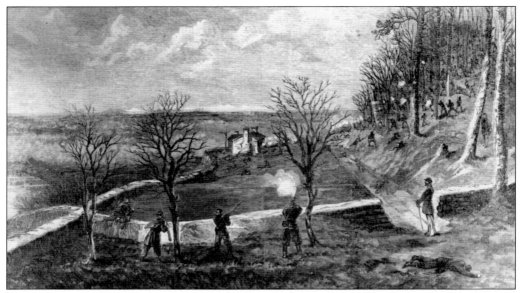

By midday, once the Army of the Cumberland reached the terrace of land where Robert Cravens had his homestead, the soldiers were able to secure this land under the Point. Written accounts by veterans indicate that, as the fog thickened on the mountain in the afternoon, it became difficult for even the experienced Confederate sharpshooters to see their targets. Unable to defend this kind of terrain for long, the Southern troops began to vacate the higher elevations, eventually retreating for good under cover of night.

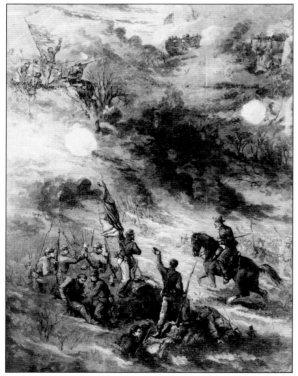

This dramatic sketch of the battle depicts the final assault on the heights of the Confederate bastion. The Southerners realized that the Union forces numbered around 10,000 troops. With only about 1,600 soldiers defending the crest, the Confederates understood that it was time to hightail it down the mountain toward Missionary Ridge to avoid capture by the enemy.

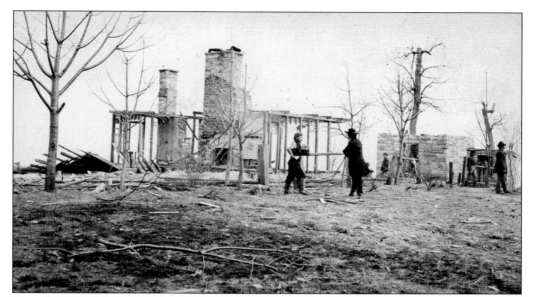

This photograph lets us see the ruins of Robert Cravens's home on what is now known as Cravens Terrace. Built in 1856 when Cravens was 50, the house was rebuilt after the Civil War in 1867 and fully restored in 1955–1957. Cravens was an enterprising ironmaster who built a furnace on the bluffs of the Tennessee River in downtown Chattanooga. Near the present-day Hunter Museum of American Art, the furnace was an early and significant industrial operation in the South for the production of coking coal.

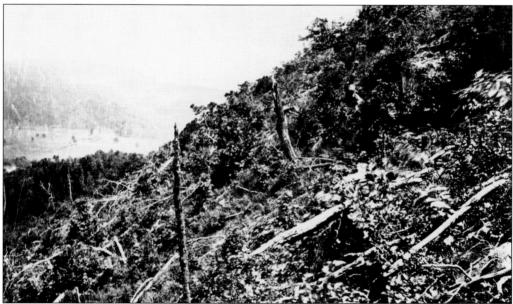

The fighting was intense as cannon and rifle roared out their thunder and tore into wooded limbs as well as human ones. The scene here reveals the damage wrought on the hardwood forest that covered the mountainside. This scene is telling when compared to other scenes a few miles away in the town of occupied Chattanooga. There the landscape was stripped bare by the multitudes of soldiers using every tree available to construct numerous buildings for the large army.

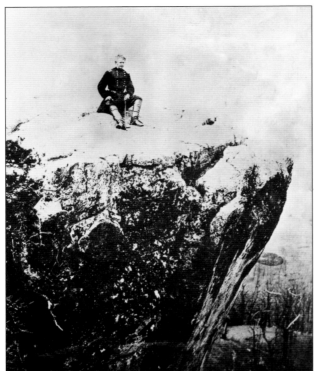

General Hooker sits astride Point Lookout and rightfully so. His attack was a thundering success and captured some significant ground, gaining laudatory press in the North as well for winning the celebrated Battle above the Clouds. For the soldier with a notable ego, this would be a high point in his career, and he would go on to fight in Georgia, though his dissatisfaction with General Sherman's command left him grousing for the rest of the war.

Ulysses S. Grant (far left) and his staff rode to the top of the mountain following the fighting of November 24, 1863, to see what they had taken and to take in the grand view of the valley and imagine the state of Georgia that lay beyond. Casual and triumphant, Grant's posture seems to indicate pleasure with the possession of this high ground and his successful liberation of Chattanooga in three quick days of fighting.

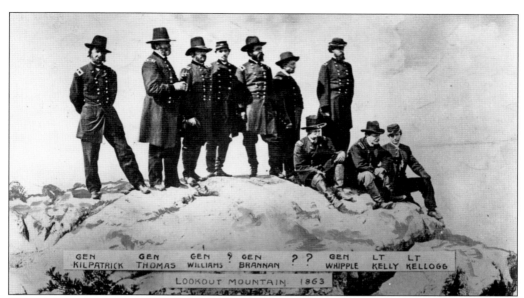

| GEN KILPATRICK | GEN THOMAS | GEN WILLIAMS | ? | GEN BRANNAN | ? | ? | GEN WHIPPLE | LT KELLY | LT KELLOGG |

LOOKOUT MOUNTAIN 1863

Though he was not part of the action at Lookout, Gen. George Thomas takes in the view of the theater of war below with his staff. A hero at Chickamauga for holding his ground against a tide of Confederates two months before, he essentially prevented a complete defeat for the Union army that day and was thereafter known as the Rock of Chickamauga for his valor in the face of overwhelming odds. His role at Chattanooga was to secure Orchard Knob, setting the stage for the confrontation at Missionary Ridge.

Some of the earliest extant photographs of Point Rock and Umbrella Rock come from the Civil War and Reconstruction period. Evidently, having one's photograph made on the tip of the mountain became quite popular for the conquering troops. Here a Union officer stands confidently on the rock with his lady, posing proudly for the camera.

A lady identified only as Miss Edwards sits on a rock while the mountainside slopes away below her. Posing a human figure in a landscape was a common 19th-century tradition in photography chiefly because it gave the viewer a sense of scale about the surrounding environment. Early descriptions of Chattanooga describe it as a vast forest, and the wooded land below bears this out. The line that cuts through the trees behind the seated figure is most likely the Whiteside Pike.

Three

BEAUTY IN ABUNDANCE

A sobering view of the valley from the 1860s illustrates the raging Tennessee River and a devastatingly flooded Chattanooga below. For countless years, the river was an unpredictable and deadly force, low in summer but able to turn into a torrential current in spring. The town of Chattanooga suffered major flooding that forced the evacuation of businesses and homes hurriedly, leaving stock and habitats heavily damaged. Threatened with this specter almost yearly, some residents began living on the higher ground that the surrounding mountains offered.

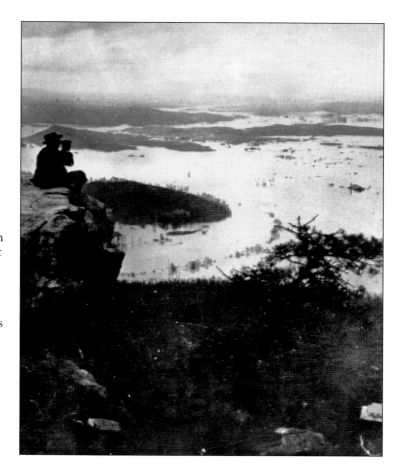

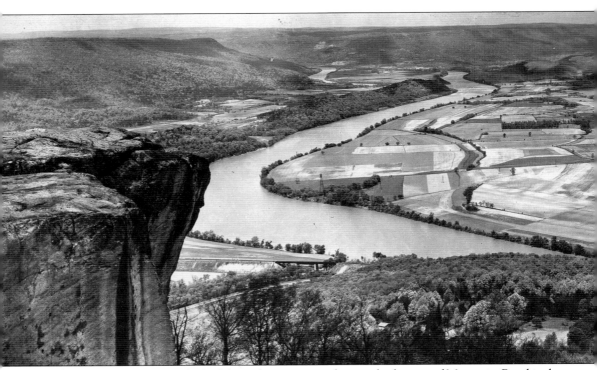

There are many views to be had from the mountain, but surely the one of Moccasin Bend is the grandest. The vista over the foot-shaped turn in the river reveals a land that has been home to human habitation for centuries according to recent archaeological discoveries. To the left of the

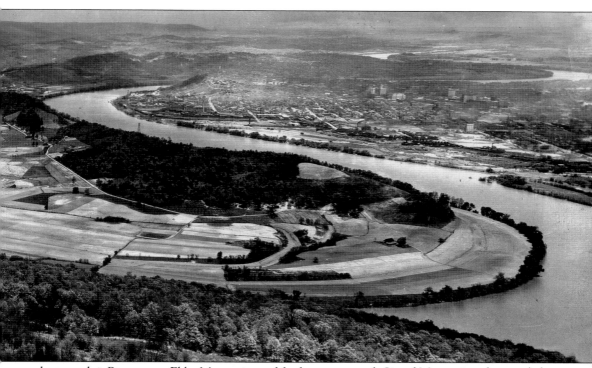

photograph is Raccoon or Elder Mountain, and farther away stands Signal Mountain, where coded messages were both sent and received by troops on Lookout's northern brow.

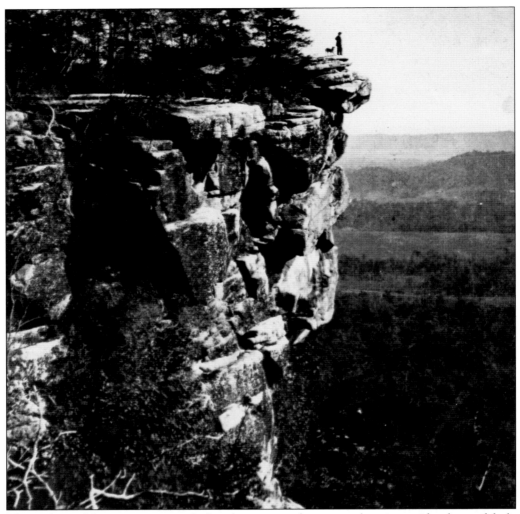

The geology of the mountain is such that there is a sandstone cap that sits astride a layer of shale under which is a base of limestone. With time, the sandstone weathers away, resulting in exposed vertical rock referred to as a palisade. This photograph, dated 1868, shows a man and his faithful dog on the Chickamauga Bluff gazing off of the east side of the mountain toward Chattanooga Valley in Georgia, not far from where the Battle of Chickamauga tumult took place. By the 1920s, it would become part of the Fairyland development.

This example of a bluff escarpment is indicative of the natural beauty of the mountain and a place where the stillness of a starry night can be enjoyed from the mountaintop. Lookout Mountain has numerous vantage points from which to enjoy the heavens, a real advantage to star gazers in an era of urban light pollution. This sheer drop is named Roper's Rock for a Corporal Roper, a Pennsylvania infantryman who tragically fell to his death from its heights.

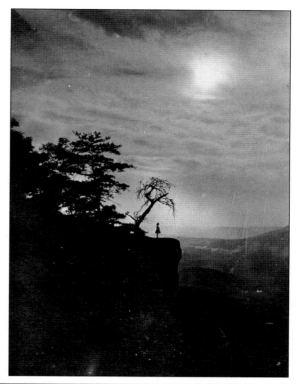

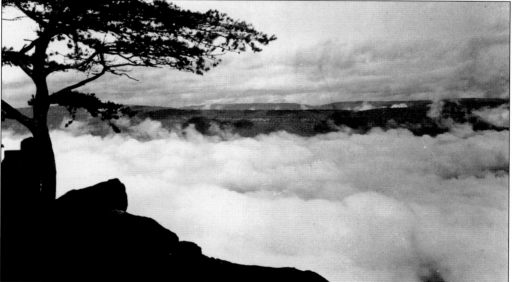

Chattanooga is a town blessed with extraordinary beauty. Spring is intensely rainy and green, fall crisp and colorful. Near the Point, or northern end of the mountain, the elevation above sea level measures 1,986 feet, meaning the mountain rises 1,300 feet above the valley floor. The northern 3 miles of Lookout belong to the State of Tennessee and are frequently the scene of foggy mornings such as this one. The highest point of the mountain is to the south at the appropriately named High Point, Georgia, which stands 2,393 feet above sea level.

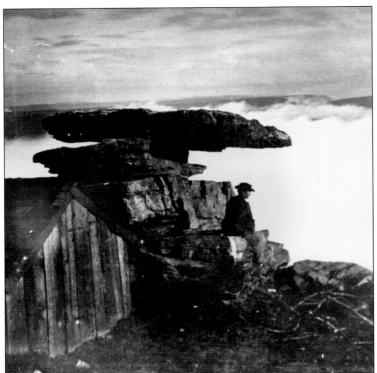

The figure in this photograph sits next to one of the loftiest photographic studios of its time. R. M. Linn, an army photographer, and James B. Linn established a studio at Point Rock on Lookout and were able to photograph some beautiful panoramic landscapes when fog or cloud did not obscure their view. Because of the moisture from the Tennessee River at the foot of the mountain and the particular height of the mountain, fog or cloud often hovers at this altitude and is understood to be part of daily life for these mountain dwellers.

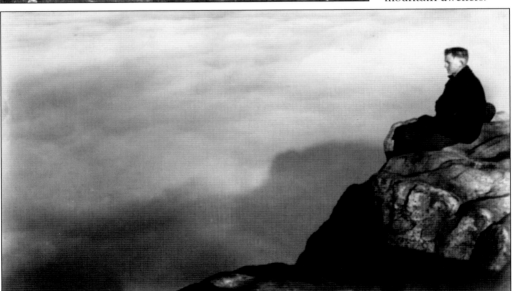

Many a child who grew up on Lookout Mountain has fond memories of the quiet and enclosed feeling present on a foggy day or a Sunday afternoon. Though it is only fleeting, these "socked in" days, as locals refer to them, add to the singularity and closeness of the community on Lookout. Eighty-three miles in length, the mountain is naturally home to many summer camps for children, especially near Mentone, Alabama, by the Georgia-Alabama line. One such summer retreat, Camp Juliette Low, named for the Girl Scout founder, has been operating since the 1920s.

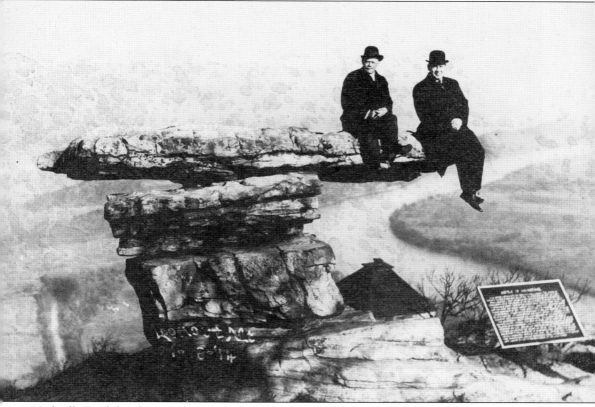

Umbrella Rock has been an attraction for visitors for a century and a half. Photographs of folks on the rock are numerous, and these two gents make a good pair. The overcoats indicate that the weather must be chilly, and in Tennessee that usually means wet. One man sits nearer the center of the rock, his hands tucked close together. His friend casually, even happily, perches on the end of the stone with apparent relish at this small feat of bravado.

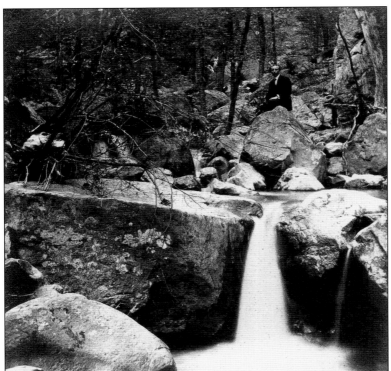

This view from 1911 shows a robust stream as it courses down the mountainside among some large boulders. Published in a booklet that includes verse and photographs, the contents are dedicated to the memory of Cyrus O. Hunt, who died in 1911, by his children. The man who appears in these images remains unidentified.

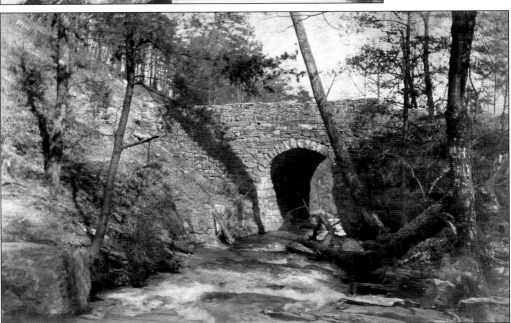

The use of natural stone on the mountain is evidence of the abundance of rock quarries throughout the region and is, of course, common in mountainous settings. Not only is this bridge constructed of native stone, but many of the residences on the mountain, both old and new, feature beautifully worked masonry facades, porches, and chimneys.

The Southern Appalachians receive buckets of rain throughout the year but most especially in the springtime, and Chattanooga is soaked to the tune of 50 plus inches annually. Plenteous springs throughout the mountain were one of the early attractions for visitors in the 19th century seeking "healthful waters." Watercourses such as Wheeler's Glen waterfall are typical of the many modest but pleasing features that dot the mountain's landscape, as this bridge over the Holman Spring Branch in Wheeler's Glen indicates.

One of the mountain's many trails is signified here and is accessible from the Ochs Highway that climbs the mountain. Named for Adolph S. Ochs, the owner of the *Chattanooga Times*—and eventually the *New York Times*—and his brother Col. Milton B. Ochs, the highway was originally known as the St. Elmo Turnpike and is known today as the road to Rock City. Adolph Ochs, one of the town's great philanthropists and Lookout Mountain resident, gave financial support to the paving and modernizing of the roadway in 1930.

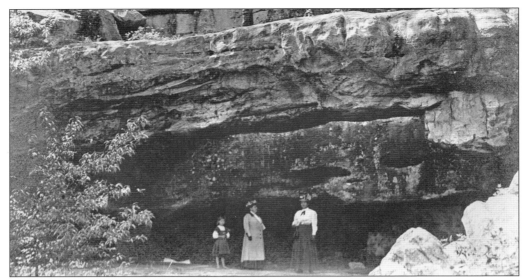

A geologic feature that seems to attract everyone is the heavy stone arch or bridge that spans a considerable distance of space, seemingly defying gravity. Such is the 60-foot Natural Bridge, where a school was located before the Civil War and later the Natural Bridge Hotel. In 1883, the site became a meeting place for a group of Spiritualists, who believed they could communicate with the dead and visualize the afterlife through trances and ceremonies. Known for their nighttime meetings among the boulders, their mission gradually faded and the property went into other hands in 1890.

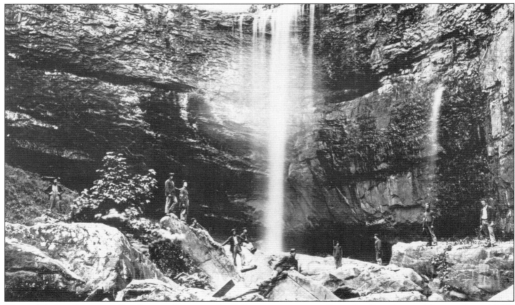

Once Federal troops had seized control of the mountain after the battle on November 1863, soldiers were sent out to scout and map the area. Five miles south of the tip of the mountain on the eastern (Georgia) side of the mountain lay Seclusion Falls, known today as Lula Lake and a well-known destination for day visits. This photograph shows troops examining the makeup of the land and enjoying some recreation and relaxation as well.

Lula Falls was undoubtedly known to Native Americans who lived in the area for many years before European settlement. This botanically rich area variously spelled as Lulu, Lulah, or Lula today remains rural. For some time, a great deal of small coal mining and timbering operations existed in the area of the falls but over time played themselves out and are now a thing of the past.

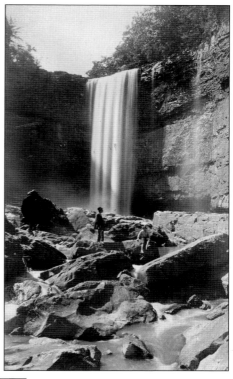

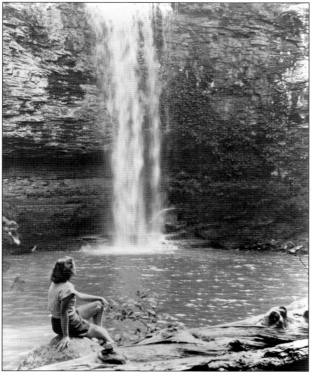

A contemplative young lady sits by the waterfall on a serene sunny day. This photograph taken in 1942 paints a lovely picture of this watery locale, but for years, the reality of the site was different. Over time, the woods and lake site became a local hangout for unsavory activities and eventually became a dumping ground for years for all sorts of debris and garbage. By the 1960s, what was once a small and wonderful spot was no longer the kind of place a family would want to visit, and only the intervention of Robert M. Davenport of Lookout Mountain would save the site as he began buying up acreage around the watercourse.

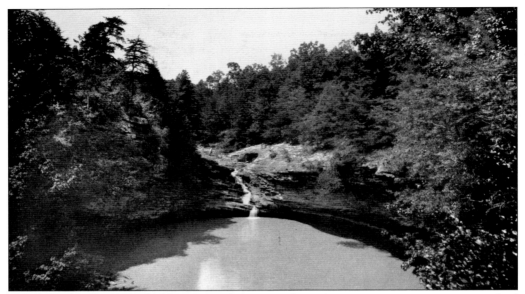

Lulu Lake, by the 1970s, had become a depressing place. At one point, someone even pushed an automobile into the lake. Only through the planning and work of local conservationists and the heroic leadership of the Davenport family was the area cleaned up and stabilized. When he died in 1994, Robert Davenport owned 1,200 acres around the area, and a land trust was formed around this property that has gradually grown to an impressive 4,000 acres. In the summer of 2009, the rejuvenated lake area was reopened to the public on a permanent basis.

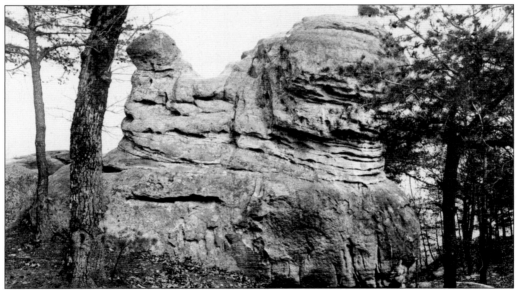

The Tennessee mountains possess an abundance of rock structures that have worn away in some unique ways over time. This one faintly resembles a kiddie auto ride the author once took at a county fair. Since rides in the 19th century were on beasts of burden, it is appropriately named Saddle Rock. The high-backed seat and pommel are in evidence. This rock is described on the original photograph as being located on East Brow Road about halfway between the homes of Mercer Reynolds Jr. and Burton Frierson.

This stone formation was given the moniker the Judgment Seat, referring, of course, to the Christian belief that a day of judgment would befall all who live on earth. Sitting in the judgment seat was serious business, and the young man resting by the rock has taken a melodramatically humble pose in deference to the implied consequences. At any rate, the structure is an impressively sized seat and certainly worthy of its somber title. It could be glimpsed by passengers on the narrow-gauge railroad that ran by the Garden of the Gods, a grouping of rocks near Sunset Depot.

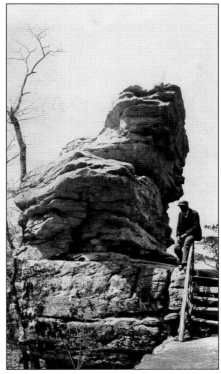

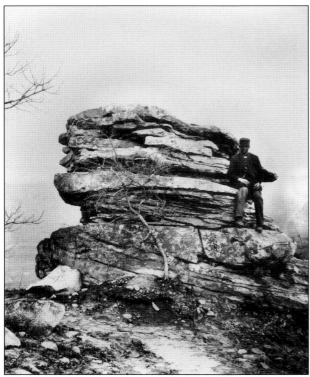

A photograph dated from 1895 looks as if it could be taken in 1865 given the fact that the young African American man is in uniform. Not only are images of African Americans from this period relatively uncommon, for the most part, they came into the army late in the war and so were the subject of even fewer images than they would have been had they served for the entire four years. This large stone has the unimaginative name of Table Rock and is similar in features to the weathered, stacked Umbrella Rock.

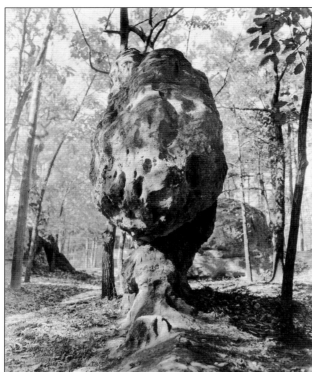

The penchant for naming these curious stone formations seems to know no end and at least some imagination. The names on the mountain run the gamut: Lion's Den, Ship Rock, Needle's Eye, and more. The title of this wonderful stone is Elephant Rock. Is the name given in deference to the size of this mighty sculpture of nature or because of the proboscis-like trunk that has captured the photographer's eye?

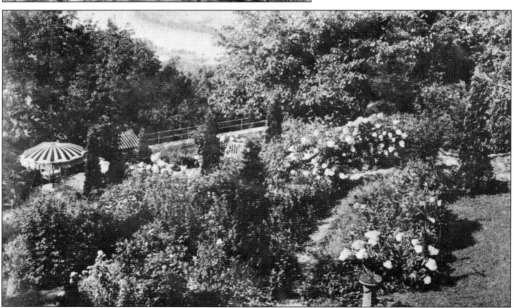

Adolph Ochs was concerned about the real estate development going on in the 1920s and thought the side of the mountain was deserving of a kind of public garden. After some planning, clearing, and pruning, the garden came into fruition. However, its appeal was lost on the citizenry, and it eventually was deeded to the U.S. government in 1934 as part of the national park system on the mountain where it remains today in a wilder state.

One of Chattanooga's true treasures is a large parcel of rolling countryside at the foot of the western edge of the mountain. Known as Reflection Riding, the land runs next to Lookout Creek and features a lovely meadow; fine old hardwoods; one wandering, graveled driving lane; a pond; and numerous boulders. On the arboretum's property is the caretaker's cabin near the entrance. The resident of this abode has 300 acres under his purview.

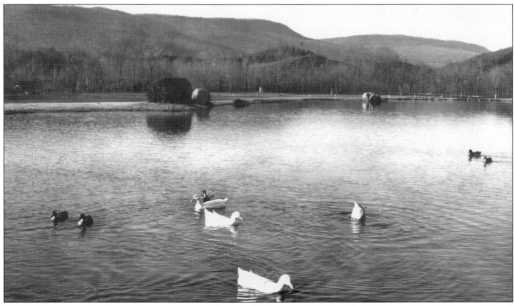

This lake is an ideal spot for a picnic and a good place to feed the ducks. In sight of this pond and the adjoining Reflection Riding is the Chattanooga Nature Center. The center is an educational facility that cares for and rehabilitates some wild creatures while teaching thousands of children each year. Near Lookout Creek, the center maintains a superbly large tree house that serves as a classroom and favorite destination on the property.

This poetic sign reflects the inspirational beginnings of this preserve. The dream of John and Margaret Chambliss, this farm site was considered as a possible manufacturing site when the Chamblisses decided to incorporate it as an arboretum in 1956. Based on the English idea of a "riding," the trails and winding paths are intended as a place of both refuge and contemplation or "reflection."

Four

THE VIEW FROM THE VALLEY

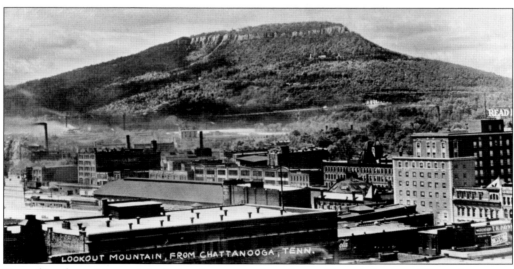

Part of Lookout Mountain's distinction comes from its profile as it is viewed from downtown Chattanooga. Not a great many cities have a mountain so integral to its downtown section. Although Raccoon and Signal Mountains are close to the city, neither has had the visual or community impact that Lookout has. Some say its imposing presence above the skyline is symbolic of the mountain's influence on political events in the city below.

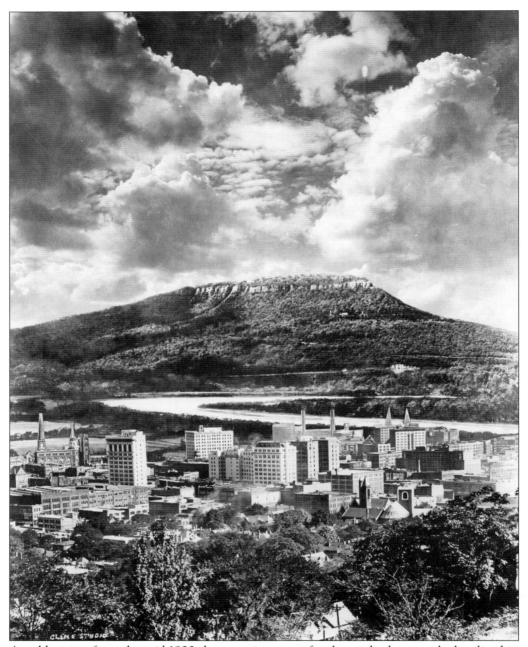

An older view from the mid-1900s has a curious note for those who have worked or lived in downtown Chattanooga because the perspective is indeed strange if not unusually foreshortened. The truth is that this photograph is a composite image that was manipulated cleverly in the darkroom so that the mountain impinges on the buildings below, appearing much closer to the city than it actually is.

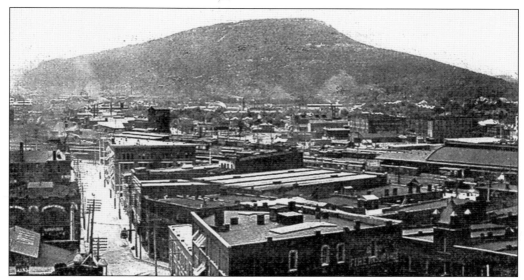

This view of the city and the mountain were taken from the roof of the Dome Building near Georgia Avenue and Eighth Street. The Dome Building—also known as the Times Building for the *Chattanooga Times* newspaper —was built to house that very paper by the owner and publisher, Adolph Ochs. Ochs himself, a generous philanthropist, was a resident of Lookout Mountain and established his career in Chattanooga before eventually acquiring the *New York Times*.

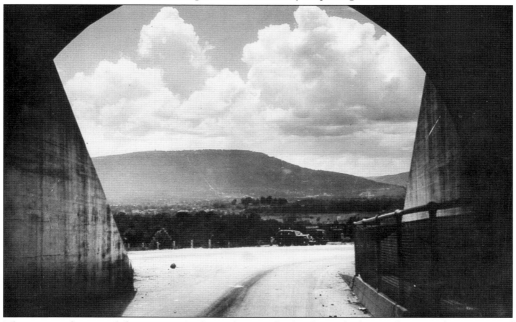

This unusual view of the mountain from the east looks through the Bachman tubes, a pair of tunnels that pierce the side of Missionary Ridge in a portion of town named East Ridge. The sight lines give a fairly accurate idea of how far away the mountain is from Missionary Ridge. It was this ridge that the Federal soldiers had to climb to dislodge the rebel forces in the final battle of Chattanooga that would bring the city under Union control once and for all. The tunnels were named for a prominent preacher and activist citizen, the Reverend Nathan Bachman.

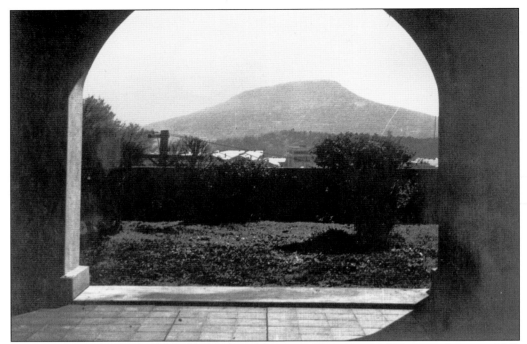

Older photographs clearly show a high hill in downtown Chattanooga. Known as Cameron Hill, it was a smaller, geologic replica of Lookout Mountain until the urban renewal craze of the 1950s destroyed its shape. In the early 1900s, it was the site of some stunningly beautiful homes, such as the Montague Mansion, the locale of this arched view. For comparison, the reader is referred to the Civil War photograph at the top of page 17, which was taken in the same vicinity.

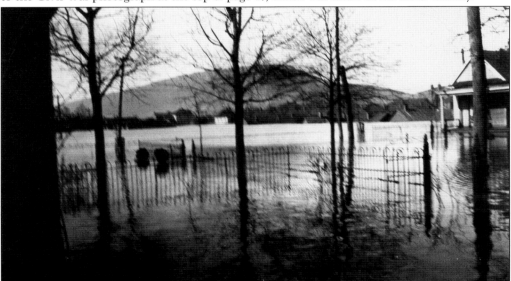

Mountaineers do not have to contend with flooding, but the folks in the valley sure do. This unusual candid photograph from what appears to be the flood of 1917 was probably taken with a Kodak box camera. Though the image is blurry, it gives a sense of the peril and distress neighbors must have felt as the relentlessly rising waters snaked through the streets and into their homes.

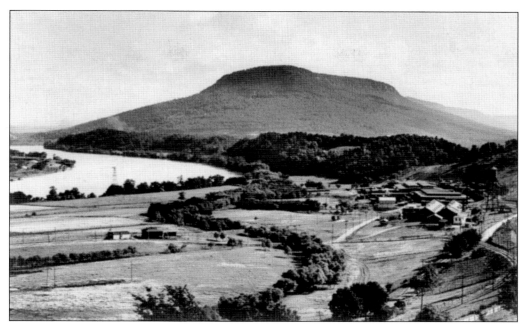

This view from Chattanooga north of the river shows the industrial development that sprang up on the river in the early 1900s. Still peppered with significant manufacturing facilities today, the area at the bottom of the photograph was part of the trail that many Cherokees were forced to walk as they left the stockades in Chattanooga on the Trail of Tears.

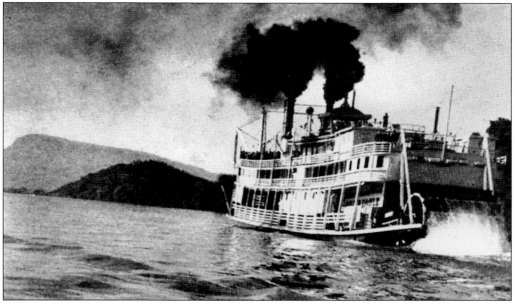

Here is a dramatic photograph of a steamer from the 1890s as it powers downstream with Lookout Mountain looming ahead. Riverboat traffic has been a busy enterprise since the founding of Ross's Landing on the river, and even today large barges laden with minerals are a common sight. Much of the river was difficult to navigate until the Tennessee Valley Authority dam program started in the 1930s, controlling the water flow and deepening the channels.

Lookout Mountain has a certain grace in its form partially because this mountain range is one of the oldest in the world and has had its rough edges worn down over millions of years. Part of the Cumberland Plateau, which itself is part of the southern Appalachians, the mountain has a northern tip that is fairly narrow; the rest of the mountain, as it proceeds in a southerly direction toward Gadsden, Alabama, broadens out and can be 4 to 5 miles wide in some places.

The Tennessee Valley can witness some stunning sunsets, and though this photograph is in black and white, it is evident that the sky overhead was enchanting against the mountain profile. Winter and early spring seem especially good times for the creation of such a streaky, evening sky that can impart a dramatic mood to the end of any given day.

Moccasin Bend today is the site of a laudable triumph in historic preservation. Recently a significant 780-acre parcel of land has been added to the National Park Service and will commemorate both the Civil War and the long Native American history on this soil. The Bend is an area that also includes a small golf course, a wastewater plant, and a mental hospital among other things. But for most of its modern history, it has been farmed and has served on occasion as a good place to shoot skeet or test out the hounds in fields and trails.

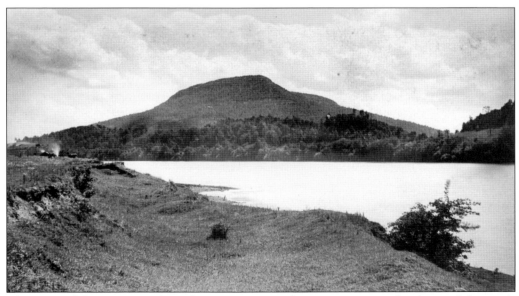

This view of the mountain from the west gives another perspective to the shape of the north slope. One of the oldest structures in the region, Brown's Tavern stands across the river, just out of range of this photograph. Built in 1803, it served as the home of a Cherokee man, John Brown, who operated a ferry that crossed the Tennessee River. During the siege of Chattanooga, the "Cracker Line" was established at the crossing by General Grant to bring in food and supplies to the starving troops trapped in Chattanooga.

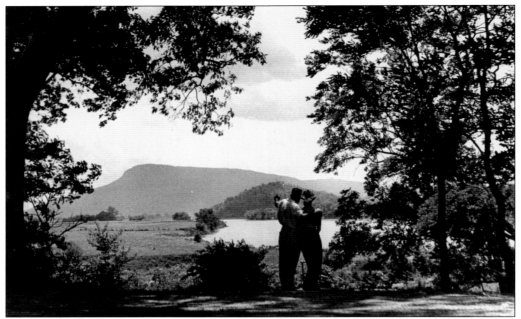

This long view from the proximity of the Baylor School campus pictures Lookout to the south and Williams Island to the right. One of the South's premier prep schools, Baylor has existed on this site since 1915. The institute sits across from Williams Island, a body of land that archaeologists have determined supported human habitation intermittently from about 1000 to 1650 AD.

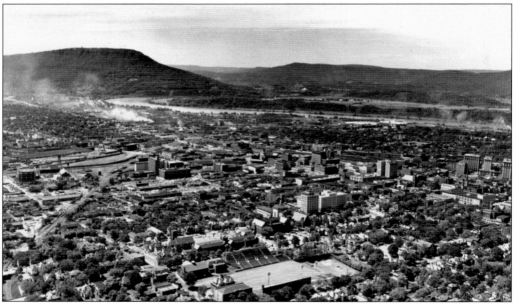

The distinctive profile of Lookout Mountain serves as a backdrop over the city of Chattanooga in this aerial photograph from 1951. The aerial perspective points toward the west with a view of the University of Tennessee at Chattanooga's Chamberlain Field at the bottom of the image. To the right of Lookout is the long line of Racoon Mountain, a favorite challenge for modern racing cyclists.

Five

RESOLUTION AND
REMEMBRANCE

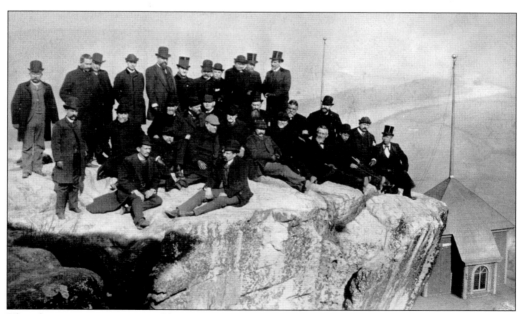

The plan to create a national battlefield park was a vision for many soldiers who had fought in the Chattanooga campaign. An enormous reunion of soldiers in 1889 solidified the idea and set in motion legislation in Congress to set aside the land for the Chickamauga and Chattanooga National Military Park that exists today. Part of the park is the land known as Point Park on the end of Lookout Mountain that lies in Tennessee. Here former soldiers pose on the mountain on September 20, 1889, during the week the gathering was held. Well-known Chattanoogans are Judge Hugh Whiteside to the far right and F. H. Caldwell on the far left.

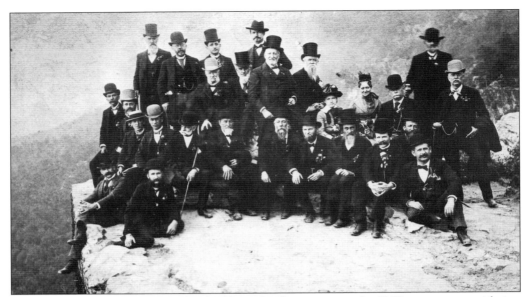

An aging generation of soldiers that had been deadly enemies in the 1860s was now considering reconciliation. On September 18, 1889, these veterans of the Civil War came to Sunset Rock to assemble and recall what transpired on that day in November 1863. In the foreground are Maj. Charles R. Evans (left) and Maj. George W. Patten. The gentleman with the high hat in the center is Gen. W. S. Rosecrans. Chattanoogan Adolph S. Ochs is in the back row, fourth from the left, and Chattanooga citizen the Honorable H. Clay Evans is fifth from the left.

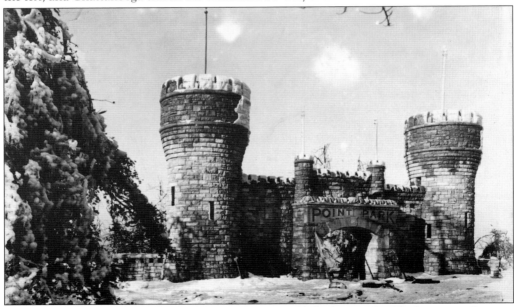

Once the Chickamauga and Chattanooga park was established in nearby Chickamauga, Georgia, work began on the acreage that would be Point Park. The idea for the park included an entrance gate and a wall made of local sandstone. As the forbiddingly cold snow of the last century swirls around its turrets, the medieval-styled towers seem to embody the storming of the ramparts of a seemingly unassailable fortress—a perfect fit for a park commemorating a military encounter.

The Chickamauga and Chattanooga National Military Park sports a number of fine monuments, and this one at Point Park is no exception. Commemorating the state of New York's efforts in the struggle, it is constructed with a beautiful, circular stepped base that supports a temple with surrounding columns. Made of Tennessee marble and Massachusetts granite, the monument's pillar is crowned by both a Union and a Confederate figure, representing the reconciliation of the two once warring sides in the War of the Rebellion.

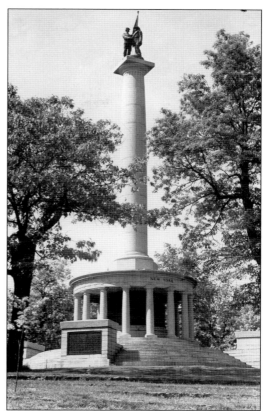

From the time Point Park was established, tourists, historians, and members of the military were constantly visiting. Commercial ventures naturally followed, one of them being the Lookout Mountain War Museum that stood next to the Point Park gate in 1907. In this photograph, gentlemen associated with a traveling circus—the Carl Hagenbeck and Great Wallace shows combined—point and pose for the camera before a large poster advertising the entertaining event to come.

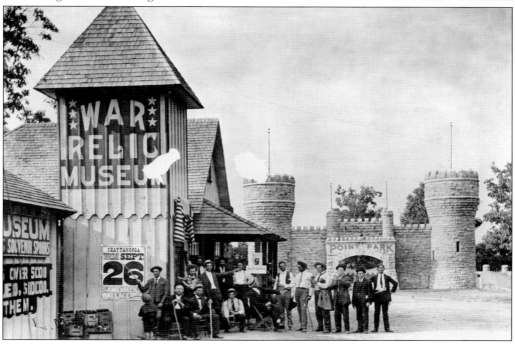

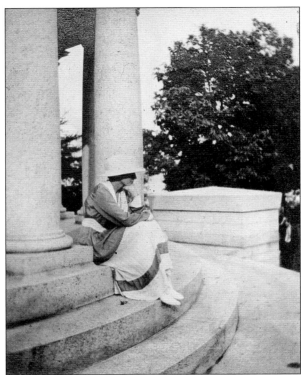

There is nothing like being bored on your vacation, which is what appears to be happening here. This stylish lady from the 1920s sits patiently, or shall we say peevishly, on the steps of the New York Peace Monument. Perhaps she is waiting for some dawdlers in her party or for someone who was supposed to meet her but has failed to show up.

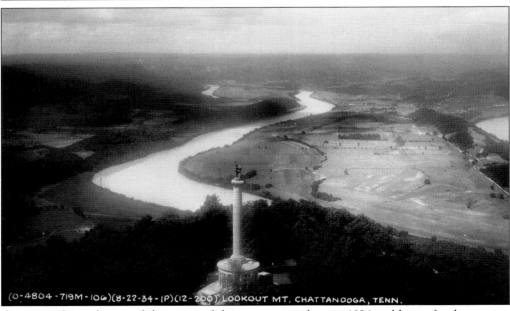

(O-4804-719M-106)(8-22-34-1P)(12-200) LOOKOUT MT. CHATTANOOGA, TENN.

An unusual aerial view of the point of the mountain taken in 1934 yields a soft, glimmering effect to the whole park. Clearly visible is the New York Peace Monument as it reaches to the sky while the Tennessee River curves away in the distance, coursing toward the Grand Canyon of the Tennessee around the farthest bend. The striking monument, which stands 95 feet high, is visible from downtown Chattanooga with the use of the unaided eye.

Years of haggling over who would control access to the land around Point Park led to a group of citizens purchasing the land, some 16 acres, from the Whiteside family in order that the public might be able to freely visit and enjoy the history and beauty of the property. One of the prime movers was Adolph Ochs, the newspaper publisher, whose name was given to this small museum in remembrance of his splendid generosity that touched so many lives in Chattanooga.

The Ochs Memorial Museum was created to commemorate the story of the Battle above the Clouds. Situated on the northern tip end of the mountain directly below Point Park, the museum allows the visitor to envision the grand march of the Union armies upward toward the summit of the mount. Dedicated in November 1940 and once a prime attraction, the museum was closed for renovations at the time this book was written.

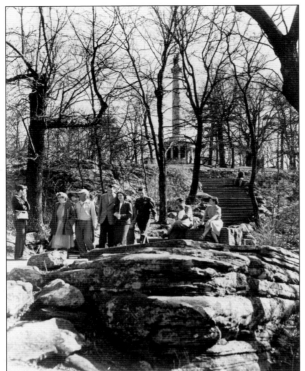

This photograph from 1942 pictures a group of people as they make their way down the trail from the New York Peace Monument (above) to Point Lookout. Tour groups are a common sight at the park, especially in summer, and can walk to the park easily from the top of the incline railway. For those who wish to stay longer, numerous trails lead from the park out to Sunset Rock, or down to the Cravens House, or just along meandering wooded paths.

The castle-like entrance for Point Park remains impressive. Designed as a classic arch flanked by two rock solid towers with battlements, the stone gateway is designed to replicate the symbol of the Army Corps. Opened in 1905, it was built by the Army Corps of Engineers and has hosted a number of famous visitors, such as Pres. Benjamin Harrison and both Franklin and Eleanor Roosevelt.

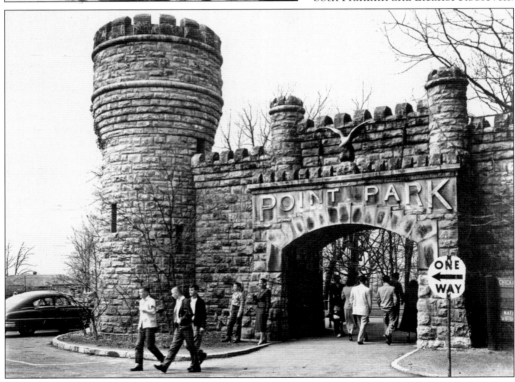

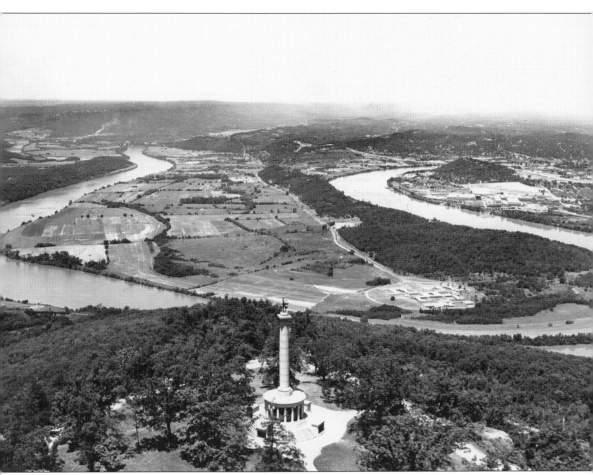

Another aerial view of the Point Park area hints at the residential nature of Lookout Mountain. The park is isolated at the end of a cozy, neighborhood area. Visitors walk by homes on sidewalks to enter the Point. Hence, visitors are welcome to visit but not encouraged to spend an inordinate amount of time in the vicinity once their curiosity has been satisfied. The scarcity of food and beverage attest to this fact. This c. 1960 photograph depicts the Moccasin Bend Hospital below and urban renewal construction in the distance.

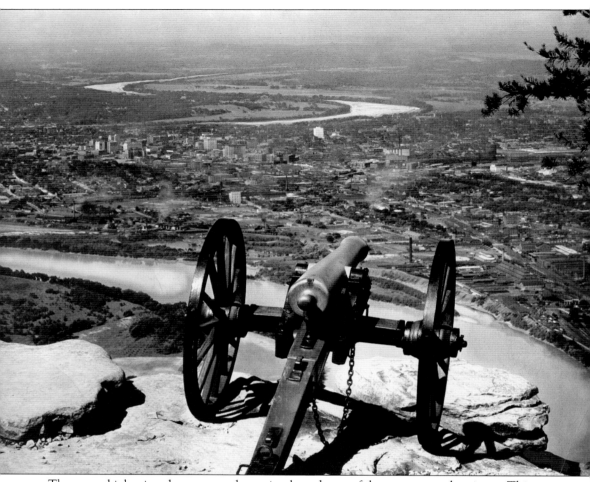

The proverbial pointed cannon makes a simple and powerful statement to the viewer. This area was once the province of the Confederacy, and this artillery, part of Garrity's Alabama Battery, was intended to keep the Federals trapped in the besieged city below. Yankee suppliers trying to use the river were to be kept at bay. To the conquering Union troops of General Hooker, this mighty piece of artillery was a symbol of the vanquished Southerners and what many would call the Chattanooga campaign—the beginning of the end for the Confederacy.

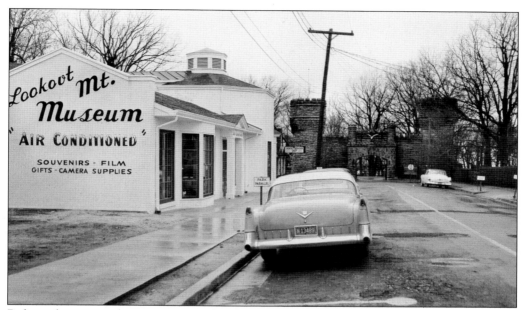

Before television and movies, a typical way to convey a historic story was through dioramas or large-scale painting that could engage the viewer for some time. The original painting inside the Lookout Mountain Museum was created for this purpose. Its wide scope and detailed depiction of the action in 1863 made the retelling of the struggle understandable and easy to visualize. The facility was slightly modernized over time and by the 1960s had become air-conditioned.

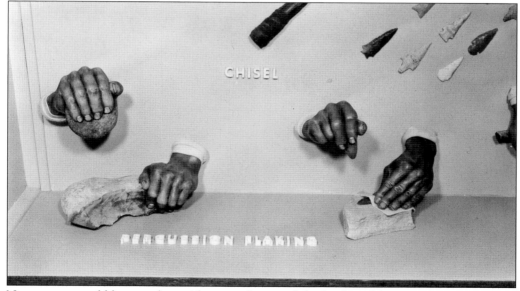

No museum would be complete without artifacts, and the Lookout Mountain Museum was no exception. Not only were Civil War artifacts that pertained to the military engagement on display, but some Native American history was incorporated from the collection of a local archaeologist as well. These deftly sculpted, disembodied hands present something of a surreal example of how arrow points were created by percussion flaking in a time before contact between European-Americans and Native Americans living in the area.

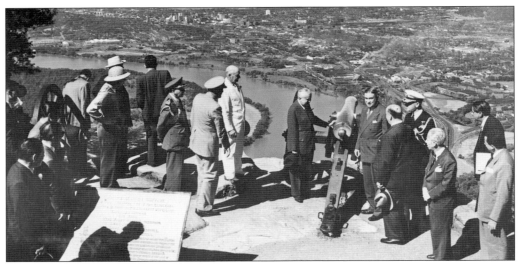

Many notable people, including Teddy Roosevelt and Babe Ruth, have visited these grounds. In May 1949, the president of Brazil, Eurico Gaspar Dutra, added his name to the roster of dignitaries who took in the city's sights. Dutra was one of the principal generals with the Brazilian Expeditionary Force in World War II. He stands to the left of the cannon, and Lookout Mountain mayor Hardwick Caldwell stands to the right. Chattanooga's elected officials often take important visitors as well as potential employers on tours of the city, either beginning or capping a tour with a visit to Lookout Mountain. Not only is this an excellent place to see the city and its environs but also a relaxed environment to carry on conversation and engage in some Southern hospitality.

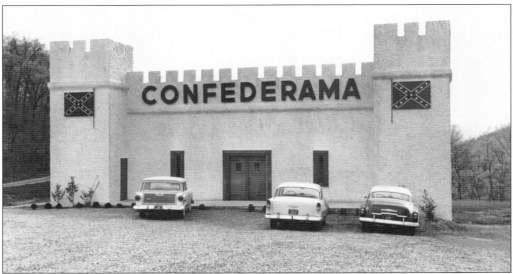

For many years after World War II, schoolchildren and visitors alike flocked to the Confederama to view the entire campaign of Chattanooga in miniature. Housed in a stucco building with faux crenellations, the elaborate display incorporated an enormous table showing the battle terrain of the city. Populated by hundreds of small painted metal figures that would light up as the narrator's voice highlighted each part of the many confrontations between the Blue and the Grey, Confederama was at home in St. Elmo for almost 40 years. In 1997, it moved up the mountain to Point Park and changed its name to Battles for Chattanooga.

Though integral to the story of the Battle above the Clouds, the Cravens House never had the tourist appeal of Point Park and needed repair by the 1950s. Somewhat off the beaten path, the house did not have the same view as the Point did and little interpretation to engage the average visitor. A citizens' group formed a committee in 1955 to restore the structure. Here discussing their plans are, from left to right, Mrs. Z. Cartter Patten, Penelope Allen, Charles S. Dunn, and architect E. W. Aschmann.

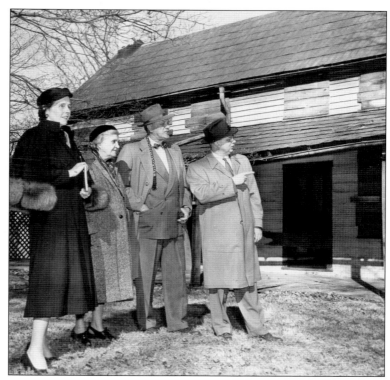

Within two years, an architectural firm had been hired, funds had been raised, and work had begun on the whole house and the detached kitchen as well. By 1957, the project was complete and the renewed site became more frequented. Today a number of trails are actively advertised to hikers and families that either connect to or cross the historic site. Here a crowd celebrates the finished task; the man next to the porch post is J. Eugene Lewis, the chairman of the restoration project.

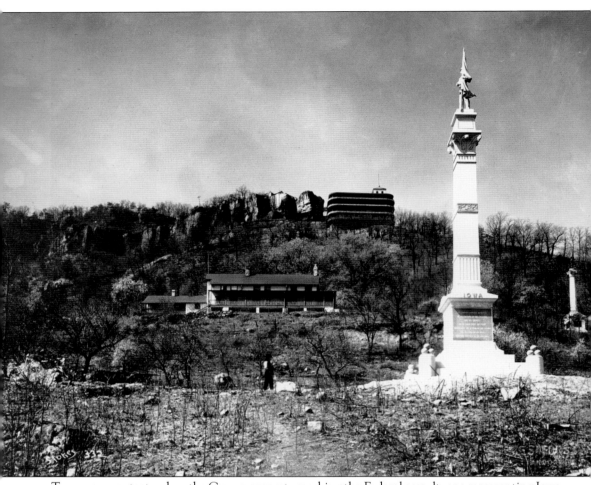

Two monuments stand on the Craven property marking the Federal assault, one representing Iowa and the other the state of Ohio. Pictured here is the Iowa monument, and near the top of the mountain stands the Lookout Mountain Hotel, which received visitors via the first incline rail built up the mountain. Most of the serious fighting on that day took place around the terrace at this house, originally called Alta Vista, which is now part of the Chickamauga and Chattanooga National Military Park.

Six

SCALING THE HEIGHTS

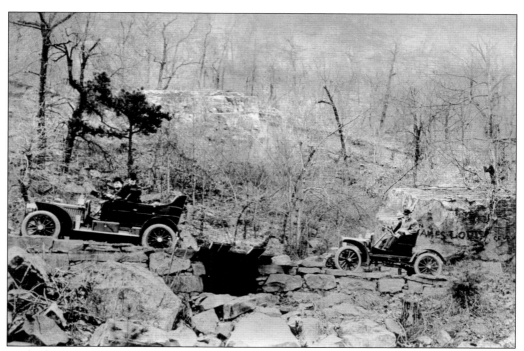

By the late 1800s, more and more folks wanted to visit Lookout Mountain. In 1909, people were falling in love with automobiles, and that year, one of Chattanooga's most publicized events was an auto race up the mountain's dirt highways. Drawing crowds estimated at up to 50,000 people, including trainloads of spectators from out of town, the race featured well-known drivers such as Louis Chevrolet. The fastest of these turned out to be Erwin G. "Cannon Ball" Baker, who flew up the mountain from the downtown Patten Hotel and back again at the serious speed of 36.22 miles per hour.

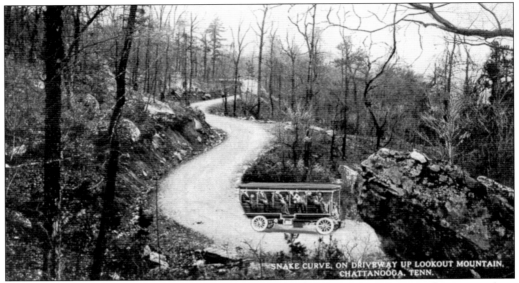

For most people at this time, automobiles—or "horseless carriages"—were a luxury, and an open tour car would do just fine. However, the continued demand of automobile drivers resulted in the creation of a Scenic Highway Association in the 1920s that pushed relentlessly for the paving and widening of roads, especially those up the mountain. The group eventually proposed a road to be called the Scenic Highway that would run on the western side of the mountain connecting Chattanooga to Gadsden, Alabama, at the southern end of Lookout Mountain, over 80 miles away.

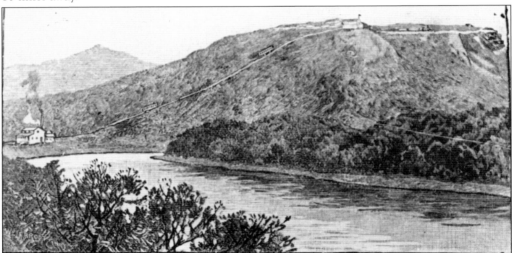

A most enjoyable ann romantic trip to the Point and Top of Lookout Mountain ; the Round Trip can be made in 2 hours, affording full opportunities for visiting points of interest

WITHOUT EXTRA CHARGE.

The race to establish control of the tourist trade for the view near Point Park had been ongoing for years before the construction of a rail line began in 1885. This advertisement announced that Incline No. 1 was open for business and that it would run from the neighborhood of St. Elmo at the eastern foot of Lookout gently northward to the newly built Point Hotel.

Lookout Point Hotel.
2,000 FEET ABOVE THE SEA.

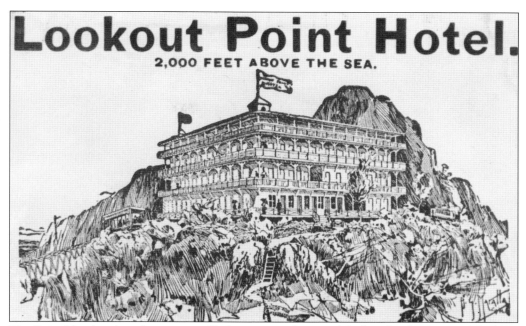

The Point Hotel with its four stories of balconies was the top of the line for the first track built up to the Point. Opened in May 1888, it was built at the height of a real estate boom in Chattanooga and claimed that the incline could reach it in only six minutes. Approximately 100 by 130 feet in dimension, it included amenities such as billiard tables and a barbershop.

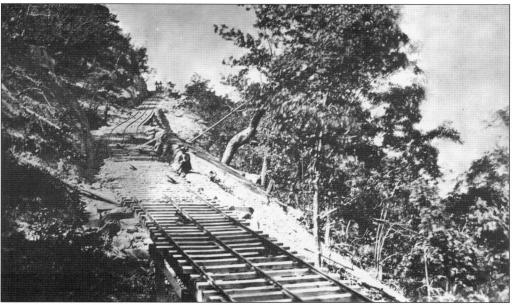

After some intense court battles between the Whiteside family, who owned much of the property around the Point, and other groups who wanted to bring customers to the Point, construction began on the line. The new line stretched over 4,000 feet and navigated some challenging terrain. The tracks were configured to allow the passing of the open trolley-style cars, which seated at capacity 35 people and were manufactured locally by the Wasson Car Works.

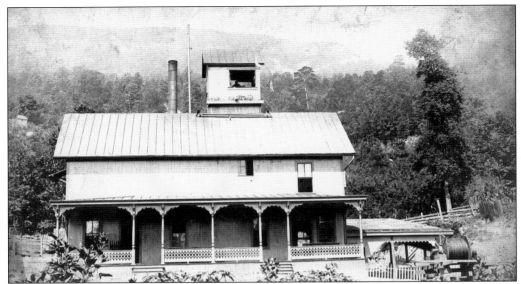

When service began in 1887, passengers would board the incline here at the depot and powerhouse, preparing to make their day trip to the Point Hotel perhaps to eat and socialize or to spend a few nights in the healthful mountain air. Advertisements aimed at out-of-town visitors claimed that only a 35-minute ride from the Union Depot in downtown Chattanooga would have the traveler at the depot and ready to relax. Excursions past the hotel to other points of interest like the Rock City were available on arrival.

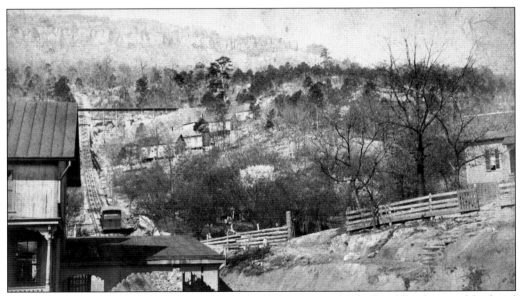

By the 1890s, the neighborhood of St. Elmo was becoming an established middle-class neighborhood with comfortable houses on large lots. Considered Chattanooga's first suburb, the planning was in large part due to the efforts of Col. A. M. Johnson who, through his marriage to Thankful Whiteside, owned a great deal of local acreage. These local rails have always been an integral part of the neighborhood and part of the reason that St. Elmo became such a desirable place to live.

The original cars were open to the weather most likely because this was a warm weather enterprise. Moreover, the belief that mountain air had beneficial properties and that higher climes in general were good for those suffering from assorted maladies had become a strong belief. This practice was reinforced by a deadly yellow fever epidemic in 1878 that had sent a number of families up to Lookout in order to escape the diseased city below.

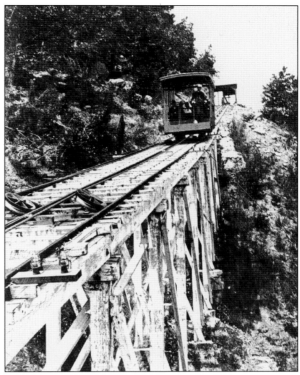

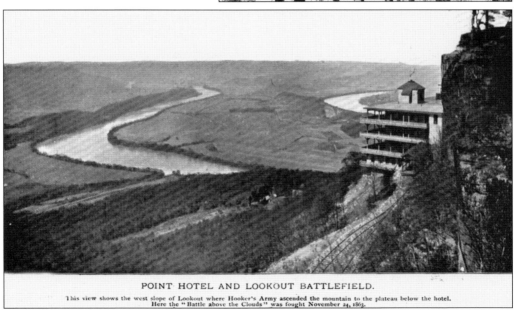

POINT HOTEL AND LOOKOUT BATTLEFIELD.

This view shows the west slope of Lookout where Hooker's Army ascended the mountain to the plateau below the hotel. Here the "Battle above the Clouds" was fought November 24, 1863.

The Point Hotel thrived from its inception in the spring of 1888. The covetous view that all had desired from the northern point of Lookout was touted in printed publications across the South and was now accessible for a round-trip fare of 50¢ for adults and a mere 25¢ for children. But the introduction of a new line, a "broad gauge" that actually crossed the new incline, was bringing people to another spot on the top of the mountain and cutting into its business.

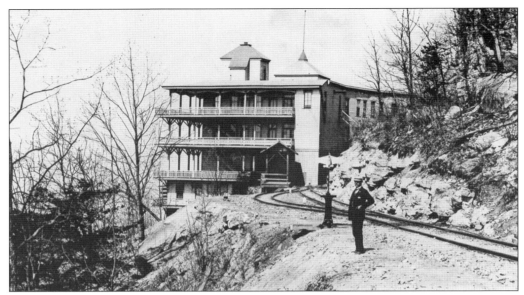

Point Hotel was a first-class operation that emphasized the quality of their service. Belgian carpets were included throughout the hotel's 58 rooms, and guests were cooled by mountain breezes and warmed by steam heat for the reasonable fare of $2.50 to $4 per night. However, the construction of the new Lookout Inn less than a mile away in 1890 quickly put a crimp in the hotel's appeal, and by 1895, Incline No. 1 was failing. The hotel was eventually forced to close and was finally torn down in 1913 as travelers sought different accommodations.

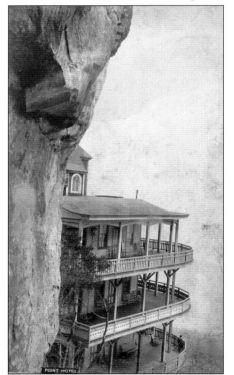

This unusual view prompts the question of how the photographer was able to swing himself into position to make this image given the sheer rock surroundings. Unfortunately the answer will remain unknown, though it is probably not that mysterious; nevertheless, the image gives us an appreciation of how tight the measurements must have been for the carpenters to assemble this pleasant hostelry.

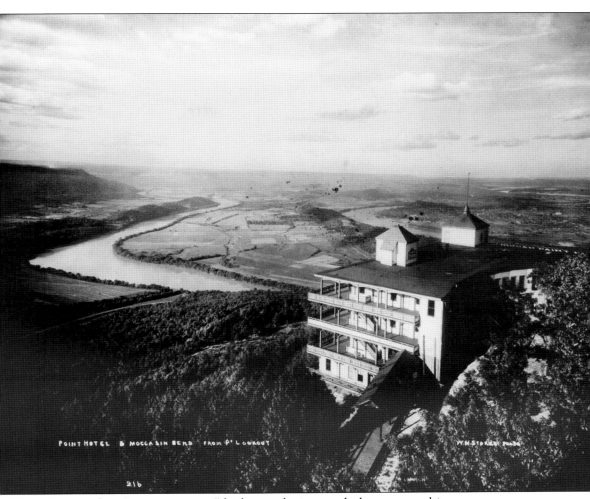

POINT HOTEL & MOCCASIN BEND FROM PT LOOKOUT W. H. STOKES PHOTO

216

In an era when "moving pictures" had yet to be invented, there was nothing to compare to a splendid view enjoyed from the perspective of a rocking chair accompanied by a full belly, and this was certainly what the hotel provided. This perspective on the valley was a welcome one because the penurious Whiteside family was not willing to let anyone visit the Point above without paying a fare, so the entrepreneurs behind the incline determined to build a hotel right below the point that would offer the view on their own terms.

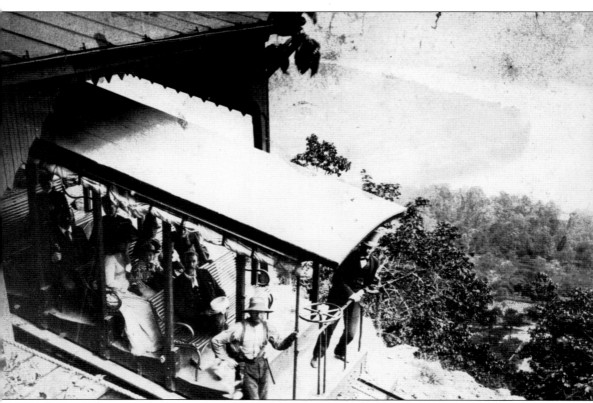

In a simpler time, this entryway via rail underneath this mountain inn almost 2,000 feet above the valley floor must have been something of a thrill. After a climb that, at its steepest, angled up 33 degrees with backward-looking seats, the journey's end under the shelter of a welcoming station must have been a pleasant finale.

As the popularity of the Point Hotel grew, a narrow-gauge line was laid past that hotel around the point of the mountain toward Sunset Rock on the western brow of the mountain. To make that run required the use of a smaller engine called the "Dinkey," shown here, that carried travelers wishing to go farther and partake of a western view.

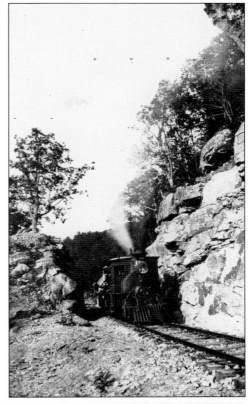

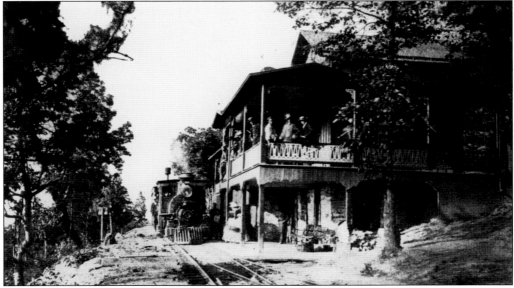

For those wanting another spot to relax, the end of the narrow-gauge line offered a smaller wayside station called the Sunset Depot. This photograph depicts the charming, two-story edifice with gingerbread woodworking around the outside balcony. The view of the westward setting sun over neighboring Sand Mountain is still a sight that is enjoyed today as it was 100 years ago.

Going up and down the incline offered riders a spectacular view. It also provided a more prosaic glimpse into the windows of houses and backyards that were quite close to the track. Another sight available to visitors many decades ago was the curiously named Garden of the Gods that stood next to the mountain rail. Well tended in its day, the rocks and greenery have now been partially reclaimed by time and nature.

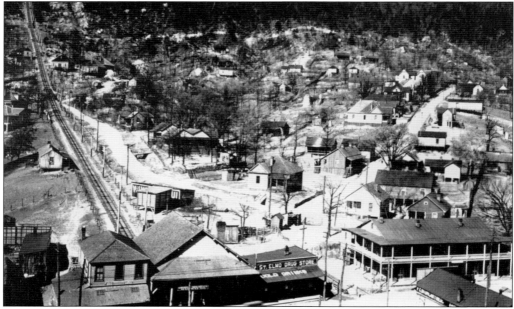

Incline No. 1 began service in 1887 and was soon followed by a broad-gauge line that stopped at a point a mile south of the Point Hotel. However, it failed to generate much income. J. T. Crass, a shrewd businessman, decided to build a third line, Incline No. 2, that would ascend directly to that more southern point and then purchased the other two lines, closing them both and leaving his new line in sole control of rail access to the mountain top.

The neighborhood known as St. Elmo is considered Chattanooga's first suburb. The completion of Incline No. 1 in 1887 encouraged its growth, and the introduction of the broad-gauge line and then Incline No. 2 solidified its success. Still an important "in town" neighborhood today, St. Elmo has seen a remarkable revival in the last 20 years with its fine bungalows, shaded streets, and shopping district seen here at the dawn of the 20th century.

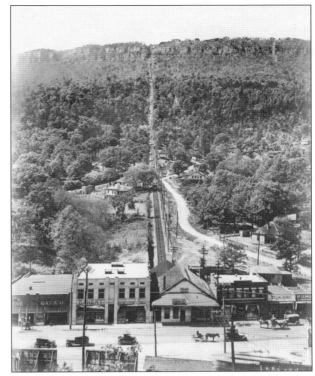

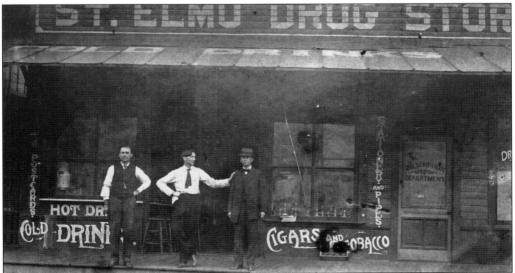

The proverbial neighborhood drugstore near Incline No. 2 was a popular neighborhood gathering spot for years. "Cold Drinks" are advertised on the front of the store, and most likely it included a new drink at the time called Coca-Cola. Three businessmen from Chattanooga convinced Asa Candler, the creator of the drink, to let them have the bottling rights for almost the entire nation, which he did for a pittance. The establishment of the Chattanooga Coca-Cola Bottling Company became the genesis of some of Chattanooga's biggest fortunes as Coca-Cola bottling manufacturers spread across the land.

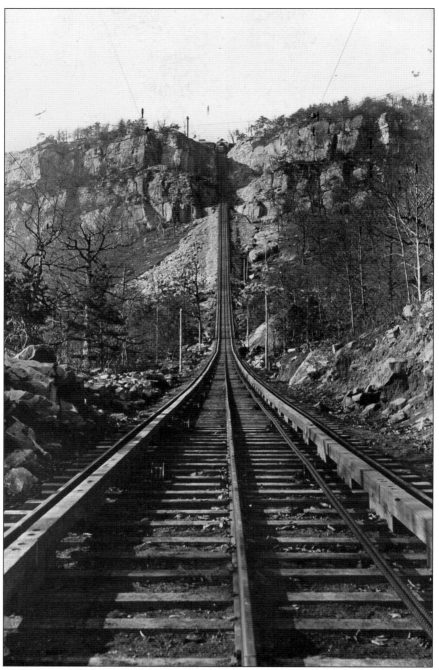

Investor J. T. Crass felt the only way to succeed with public transport was to build a more direct line up the slope of the mountain, and straight up the mountainside he went. As soon as Incline No. 1 became popular, he and other planners became interested in becoming part of the boom to invest in Lookout Mountain. Even though there were already two roads up the mountain—the old Whiteside Pike and the St. Elmo Turnpike (later to become the Ochs Highway)—the rails served a purpose and still do today.

This excellent photograph was taken by the Hardie Brothers studio. The two brothers from Michigan were prolific in Chattanooga at the dawn of the 20th century before moving on to other towns to ply their trade. The sheer steep slope pictured here was intimidating enough to discourage most builders, but Crass nevertheless determined he could succeed and in November 1895 opened his third, more direct line, believing his "faster" ride would lure customers his way—and he was right.

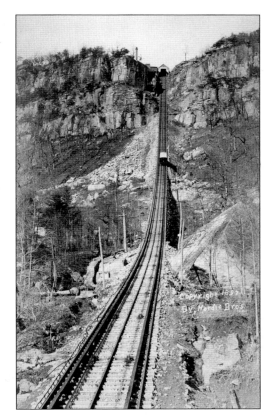

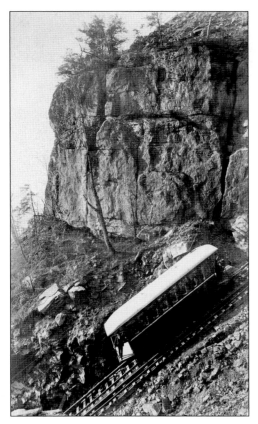

This photograph displays the degree of difficulty the engineers must have encountered, not only as they planned the line, but as they had to finish it especially at the top. One factor that certainly helped Crass's Incline No. 2 succeed was the fact that the magnificent, four-story Lookout Mountain Inn had opened in June 1890 on the top of the mountain, and it literally sat across from the depot that served the incline.

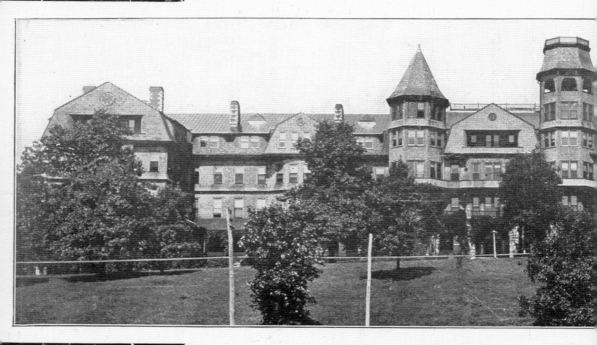

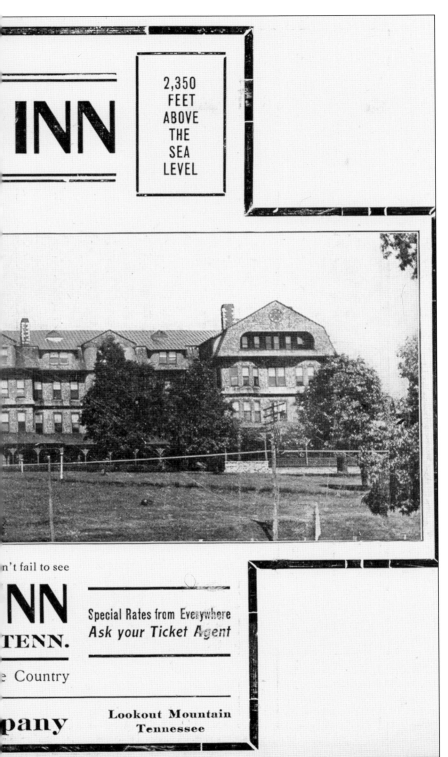

INN

2,350
FEET
ABOVE
THE
SEA
LEVEL

n't fail to see

NN

TENN.

e Country

pany

Special Rates from Everywhere
Ask your Ticket Agent

Lookout Mountain
Tennessee

This amazing hotel—over 100 yards long, the length of a football field—opened in 1890 to much fanfare and for good reason. Four stories high with two towers, the taller of which was 96 feet, it was a striking-looking piece of architecture with parlors, fine dining rooms, beautiful woodwork of oak inside, and a bowling alley in the basement plus its own electric and gas plant.

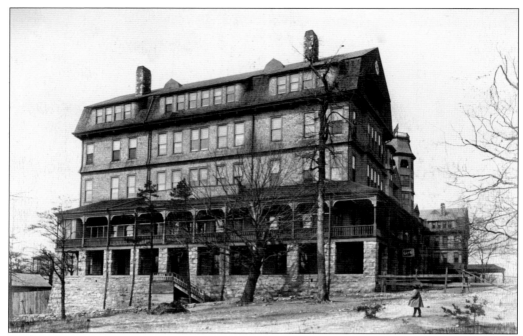

A photograph of this little girl standing by the side of the inn gives an idea of the size of this beautiful building. Staffed by as many as a dozen cooks and 60 waiters, it was a mecca for some spectacular dinners and other social events—one dinner on record seated 500 people.

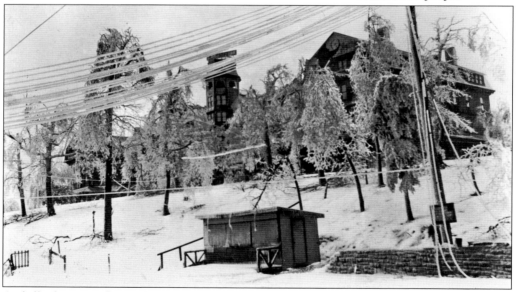

A chilly day gives the Lookout Mountain Inn a ghostly appearance as a bitter ice storm covers the mountain. Though the inn struggled financially, it remained a regional landmark for almost 20 years. Then on November 17, 1908, a fire broke out in the afternoon that spread quickly. With little firefighting equipment nearby, the inn became a raging inferno and burned into the night, visible for miles and miles to all in the valley below. By morning, it was charred rubble and only a grand memory in the city's history.

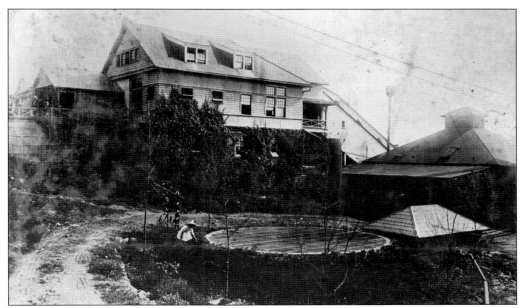

The station at the top of the incline was a finely constructed building with observation decks and some sundries for sale. Riders were encouraged to spend some time at the depot, walk across to the Lookout Mountain Inn, or go down the street to Point Park to spend some time remembering the Battle above the Clouds. The station pictured here is the second one built on this site, the first one having succumbed to an electrical fire.

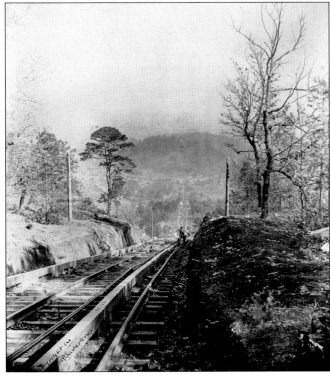

This view re-creates the feeling of the swoop of the rail line as it plunges downhill. Many a first-timer—and for that matter a second-time rider—gets the "willies" looking down the long stretch of rail as the car begins its trek. That feeling is often amplified when the car makes a slight lurch, as it sometimes does when the tension in the cable relaxes a bit, and gives the rider a jolt.

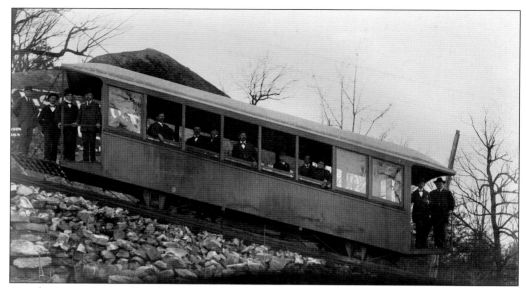

Are these people standing for the photographer or for the occasion? All public beginnings are accompanied with some fanfare, and this was no exception. Important people attend and speeches were made to commemorate a special day. Little did anyone realize on November 16, 1895, that Incline No. 2 would be going about its business 114 years later, and probably only J. T. Crass knew it would be the only incline on the mountain two years later. (Hardie Brothers.)

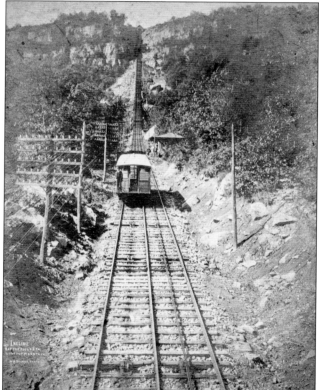

Though the work is probably routine, all trains must have a conductor. The track is almost a mile long and the ascent at the top is a 72.7-percent grade, reputedly the steepest angle of any passenger train on earth. With the seats facing backwards, or looking down, the feeling of the tilt at the top is something that makes even the seasoned traveler grip the chair handle a little tighter.

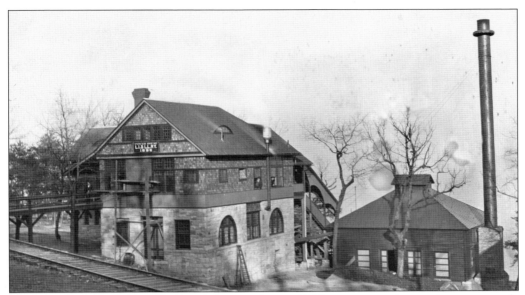

The powerhouse contains two motors that weigh in at 100 horsepower apiece and are constantly maintained. Their strength, combined with the overly strong steel cables and a brake system in the house and on the cars as well, ensures a safe passage for each trip. The original steam motors gave way to electric motors in 1911, and aside from one fire, the incline has an excellent safety record.

Building Incline No. 2 was a job for men with mountain railroading experience, and George Duncan was the man chosen to do the work. Josephus Conn Guild did the design work, and the job was completed almost at the same time that the Chickamauga and Chattanooga National Military Park was opened. Harriet Whiteside, who owned most of the Point Park property, was also an investor, basically because she was opposed to Incline No. 1 and its infringement on the viewing rights that came with her property.

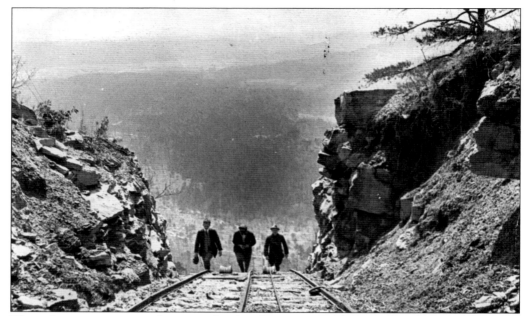

These three men are part of any sound railroad operation trudging as they do up and down the tracks looking for faults, scanning for buildings errors or problems. Like the postal carrier, their work goes on regardless of weather, and since the incline runs continually, it requires constant checking regardless of the fact that they are climbing a seriously steep grade.

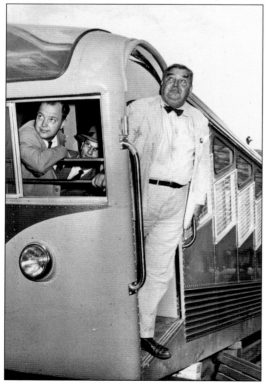

Jo Conn Guild, an important figure in Chattanooga history, leans out of a new rail car. Prominent in business and civic affairs, he was president of the Tennessee Electric Power Company or TEPCO, as it was known. Before the Tennessee Valley Authority began constructing dams in the 1930s, his company built the Hales Bar Lock and Dam in 1913, becoming the first mass producer of electricity for the local region.

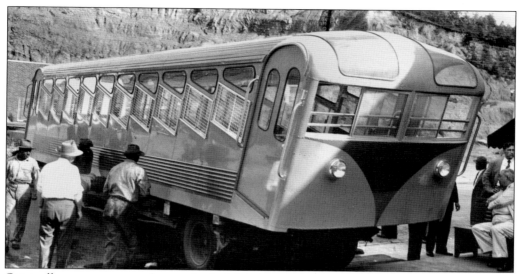

Originally open cars were the standard of the time on the mountain inclines, but as year-round service took hold and weather was a consideration, covered cars became the norm around the turn of the 20th century. Decades of wear took their toll, however, and more modern cars became the order of the day. Here the new cars get a thorough going-over from local patrons during their first day on the job in 1949.

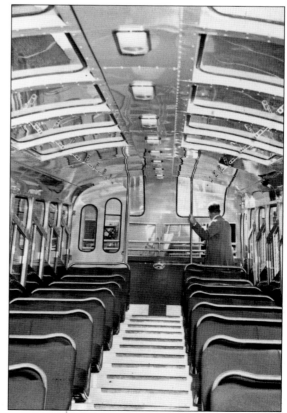

The cars in use today came into use in 1987 and are similar to the ones that were produced in 1949, made of steel and manufactured locally. The interior is clean, gleaming, steep, and has a design that is unmistakably from the postwar period. By this time, the automobile was the common mode of transportation and an appearance attractive to the ever increasing tourist trade was important.

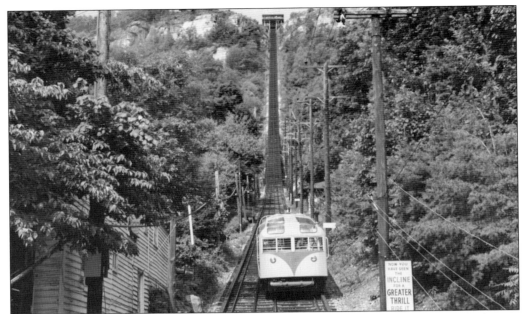

One simple childhood memory of this author is that of watching the cars' slow but steady descent toward the St. Elmo station. Like any train, the size changes from a tiny form far away to a bigger-than-life transport once it arrives. By the 1960s, the incline's circus-like slogan of "America's Most Amazing Mile" was an established phrase that appeared on everything from billboards to postcards.

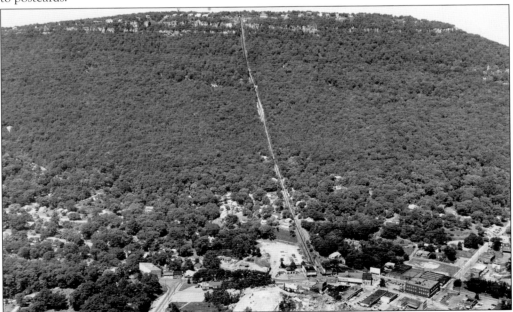

The length of the incline is impressive when seen at a distance, as this photograph shows. Since 1973, it has been part of the Chattanooga Area Rapid Transit Authority (CARTA) and as such, the incline has been able to keep its fares reasonable and its schedule regular. Though its riders tend mostly to be visitors, the line still serves local residents who live and work in the vicinity.

A view from the top reinforces the spectacular piece of work that is the incline rail. Not only is the longevity of the operation impressive, but the transportation achievement was officially designated a Historic Mechanical Engineering Landmark by the American Society of Mechanical Engineers (ASME). The award was presented at a ceremony held on September 11, 1991, in Chattanooga, something that would have certainly made the original crew of engineers and laborers proud.

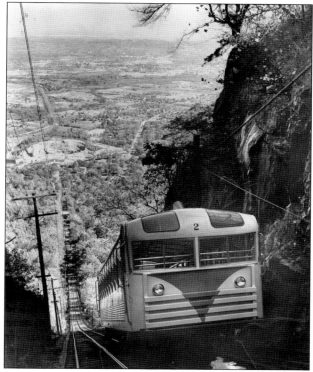

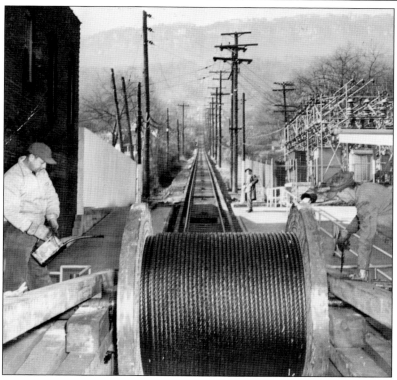

The linchpin of this operation is of course the steel cables, which are operated by powerful motors. Each of the lines can pull 70 tons, each is 5,000 feet long, and either one is capable of pulling both cars if one line were to snap.

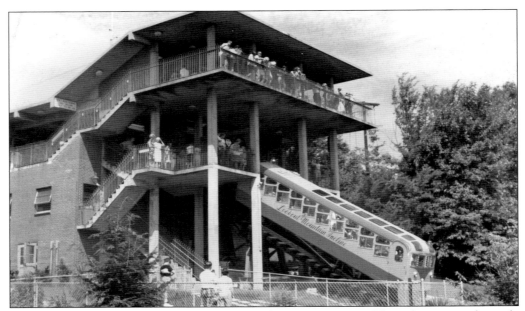

Life at the top of the rail has changed somewhat from a century ago. The rail station is obviously a more modern concrete building with a platform up top for spectators, and the upper deck has those ubiquitous two-eyed, metal, heart-shaped binoculars that eat quarters. Inside, the souvenirs are a little more varied than the whittled items of long ago, now ranging from pennants to key chains to assorted junk food and, of course, T-shirts.

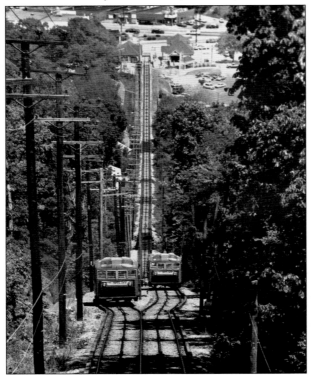

About halfway down—or halfway up, depending on your point of view—the ascending and descending cars each take a short side track that lets them politely pass each other. Passengers are known to greet each other through the windows as each car chugs by to its destination before changing directions to do it all over again.

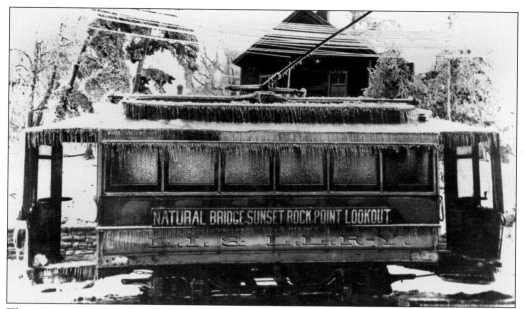

The worst winter storms in the mid-South are not snowstorms but ice storms, especially ones that surprise everyone in early spring. The mountains around the valley fare worse than the lowlands naturally because of elevation but also because of the ripping winds. This car was a frozen victim of the 1904 ice storm; it served as a local line that went to spots such as Lula Lake and the Natural Bridge, having been put into service after the inclines were established.

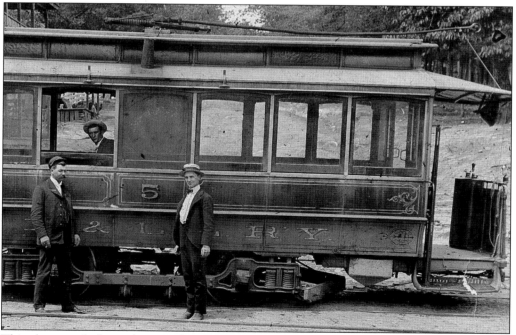

This photograph shows the same line in warmer weather. Though trolleys in Chattanooga were mostly a downtown phenomenon, they were used at different times on the mountain and were sufficient until most residents preferred automobiles instead.

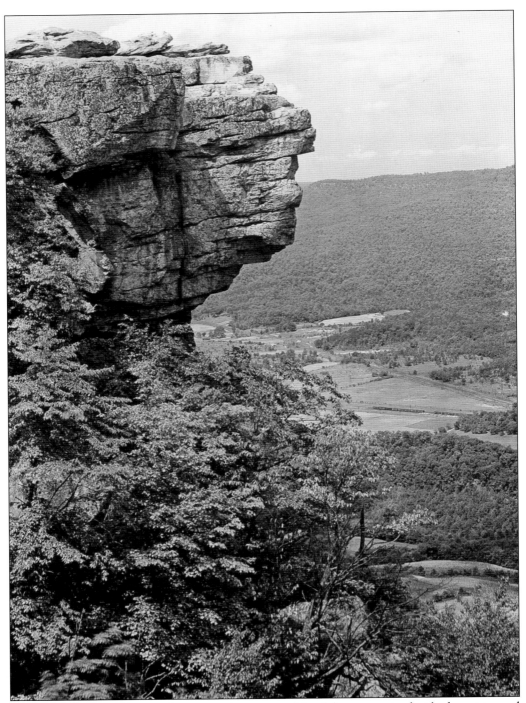

Sunset Rock is a well-known feature on the western side of the mountain that looks out toward Sand Mountain across Lookout Valley. When seen from below, it resembles a human face and is often characterized as that of a profile of an "Indian chief" and accompanied with a tale from "long ago" that is most likely fabricated by local storytellers practicing their craft.

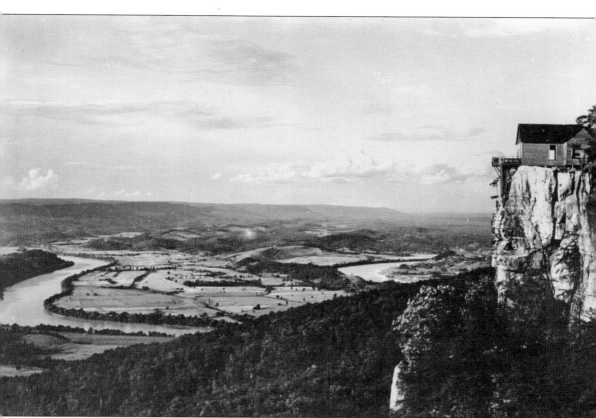

Certainly this location for a photographic gallery has to be one of the more unusual settings in American history. The Linn family were the first photographers to set up on the mountain side, with a studio at the Point and then later at Sunset Rock. They were followed by the Hardie Brothers and actually swapped studios at one point. The view and setting were inspiring, but sitters for outdoor portraits were always cautioned not to back up too far.

These two men do not seem interested in catching a ride on the rails but rather spending some time contemplating something else. This site most likely is not Incline No. 2 since the straight sight lines would make it quite obvious to the conductors that interlopers were perched on the track.

Seven

LIFE ON THE MOUNTAIN

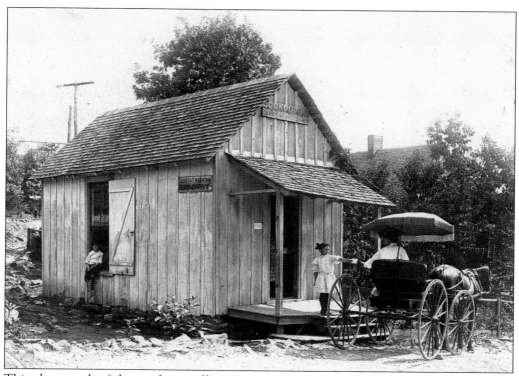

This photograph of the rural post office almost seems out of sync with the idea of a Lookout Mountain swarmed by herds of curious tourists and real estate developers, but the early days of daily living were for most folks simple and rural. Older citizens still talk of walking everywhere, riding the incline, and traditional family life. The post office—often run by a family—even in the 20th century was a community place to gather and exchange news.

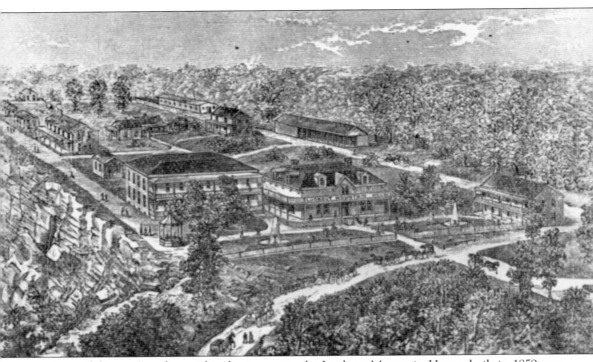

One of the area's early social gathering spots, the Lookout Mountain House, built in 1859, was located on the eastern side of the mountain where the Whiteside Turnpike topped the rise. Quite popular in the 1880s, it was run by the Whiteside family for years. When it burned in 1921, the famous newspaper man Jerome Pound built a home on the site called Stonedge that was so admired it was reproduced on postcards.

Edward Young Chapin (center), a great supporter of Chattanooga's public library, was a well-respected and civic-minded banker in town for decades. This fine studio photograph shows him with the manager of the Lookout Mountain House, George Purvis (left), and Philander Sims, one of the founders of Erlanger Hospital and one of several medical doctors to be mayor of Chattanooga.

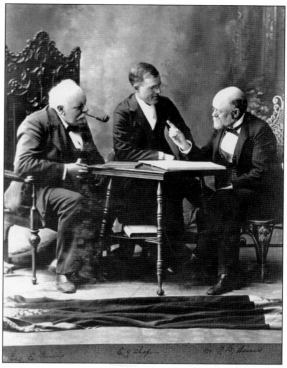

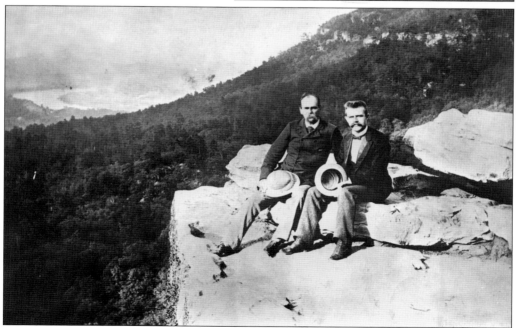

Whether rich or poor, famous or unknown, part of life on Lookout Mountain involved having one's photograph made on a rock, in this case Sunset Rock. Here visitor Prentiss Ingraham (right), a popular 19th-century novelist and short story writer, is shown on Sunset Rock with his host, E. Y. Chapin, who was president of the American Trust and Banking Company in Chattanooga.

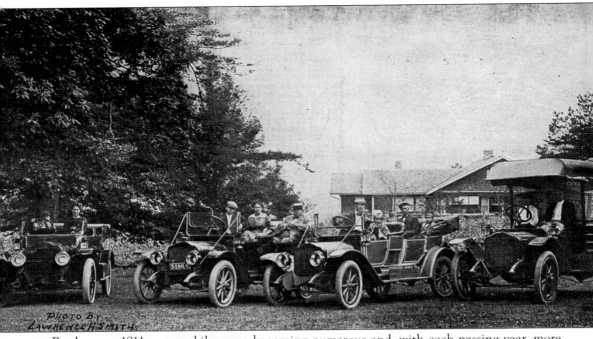

PHOTO BY
LAWRENCE H SMITH

By the year 1911, automobiles were becoming numerous and, with each passing year, more affordable for more people. Needless to say, Lookout Mountain had its share of fine gas cars as is obvious from this group lined up for the camera. Among the notable citizens here are several

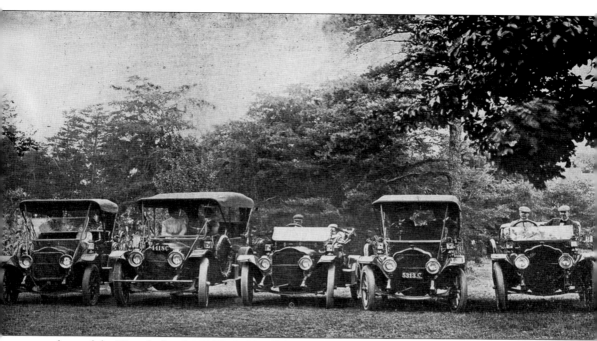

members of the Temple family, F. H. Caldwell (second vehicle, third from the left), and Garnet Carter (sixth vehicle, second from the left), who no doubt were among the active proponents for better quality roads for their top-flight vehicles.

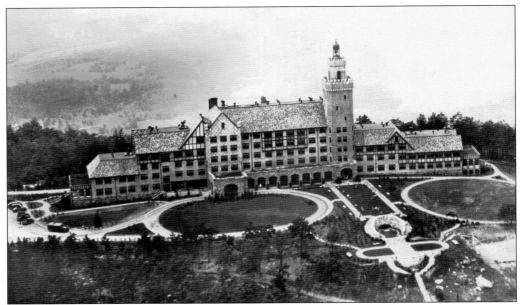

The Lookout Mountain Hotel was an ambitious undertaking that took place in the boom years of the 1920s and coincided with the movement to build the Scenic Highway on the mountain, a road that would connect Chattanooga, Tennessee, to Gadsden, Alabama. Constant political pressure by local citizens made the road a reality, and the handsome hotel on the highway known as the Castle Above the Clouds opened in 1928.

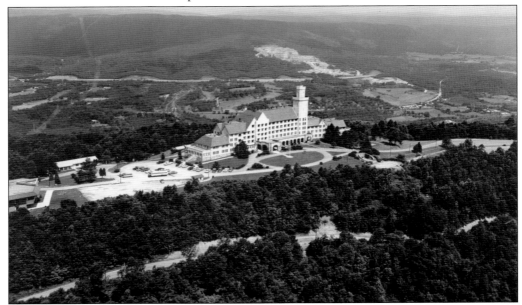

As grand as the vision was for the hotel, the Great Depression was grander. The hotel struggled for years and was closed several times. By the early 1960s, the building was a white elephant in the travel world and was purchased in 1964 by Covenant College in St. Louis, who relocated their Christian educational institution to the sprawling facility. The exterior was stuccoed and dormitories were added, and today Covenant is a thriving four-year college.

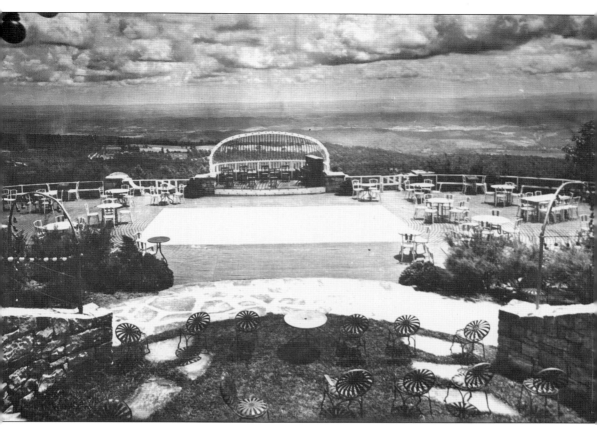

Hundreds of guests feasted at the inaugural dinner that was coordinated by the Dinkler Hotel staff. The idea of a healthy, high altitude environment was echoed by Paul Carter, the owner of the hotel, who claimed the spot would bring "surcease to jumping nerves, jaded bodies, and drooping spirits." Interestingly enough, the 400-foot tower contained an intense lamp that beamed its light into the night sky as far as 100 miles away.

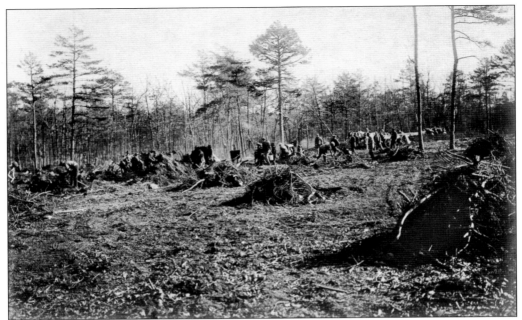

Men and muscle go to work to clear the heavily wooded land on top of the mountain for what was known as the Fairyland development. Believing that the tourist trade was a growing phenomenon, Garnet Carter, along with O. B. Andrews, drew up plans for this property in the early 1920s, with plans for a hotel on this site to be known as the Fairyland Inn.

Steady work with the timber man's axe reveals a great deal of progress in clearing the forest. Still, a goodly amount of stump removal and grading remained before construction could begin on this site, photographed in 1924. Promises of a golf course and greenways were made to lure buyers to purchase land even though no construction had been done.

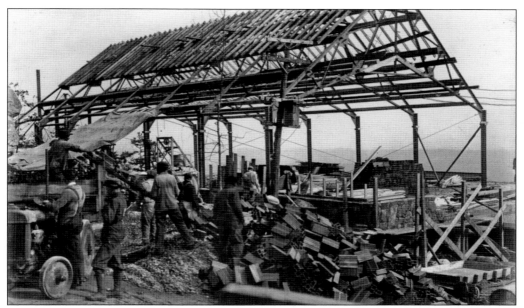

A great deal of building was going on in Chattanooga in the 1920s, and the Fairyland Inn was one of the more elegant projects. In this view, workers unload a truck of masonry materials at the inn's side as construction moves forward. Some of the exterior stone wall is taking shape. The timber joists of the roof are clearly visible as haulers, masons, and carpenters labor to complete and cover the top of the building sometime around 1926.

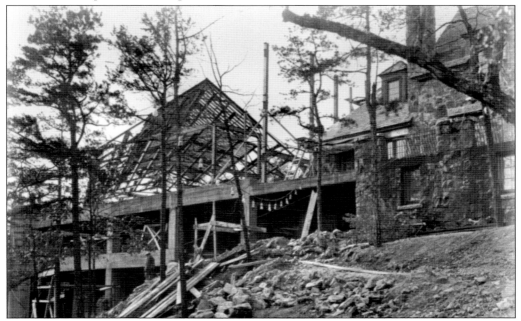

This view of the construction depicts the building as it runs along the edge of the mountain. Hoping to capitalize on the growing number of tourists that traveled the Dixie Highway at the foot of the mountain, the inn was sited beautifully and offered an expansive view of the valley below to its patrons.

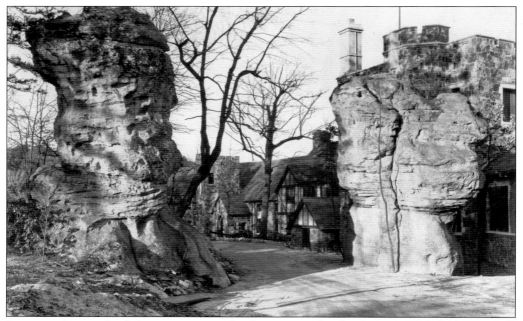

Incorporating much of the existing stone landscape puts this development ahead of its time. It would be incorrect to say the builders had a modern environmental conscience, but it would be fair to say that the developers had a respect for the beauty of the "Rock City" and imaginatively interwove these boulders into the built environment.

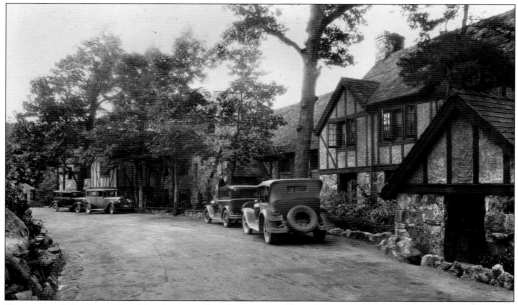

Carter and Andrews had both considered going to Florida to pursue the first huge real estate boom of the 20th century but instead decided to stay home. Purchasing 450 acres in the Rock City and the Chickamauga Bluff areas, they decided that an inn at the center of the project would be a statement as to the quality of their work. The first auction held in the city proved them right when leading citizens, including the governor of Tennessee, bought lots.

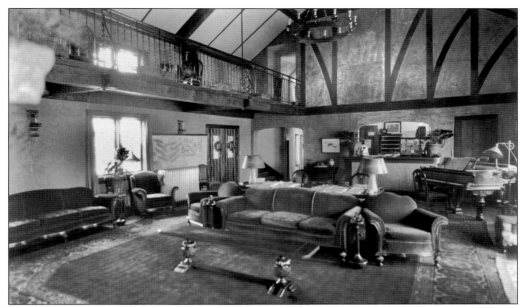

Auctions in Miami and Atlanta further encouraged people to get in on the new development, and the stone inn opened in the summer of 1925 with outdoor dancing and dining. The interior lobby and rooms were custom designed, and the next year, a ballroom and an outdoor swimming pool were introduced. The golf course came to fruition in 1927. Prestigious Chattanoogans such as Z. C. Patten and J. B. Pound became homeowners as well.

The inn was quite a showplace during its earlier years and the center of a number of social events, with big name bands coming from out of town to entertain and dining and dancing as well. The good times came to an end, however, in the 1930s, and the inn converted into a private club and remains so to this day. Nevertheless, the wealthy residents of the mountain have been able to sustain it grandly and the club remains one of the most prestigious in the South.

Though construction was underway, the golf course was not yet completed. Carter, almost as a lark, one day put together a small putting green for some residents, who took to it immediately. Grabbing some pipe that was laying amongst some building material, he made a small or "miniature" golf course and called it "Tom Thumb Golf." It quickly became a popular local phenomenon.

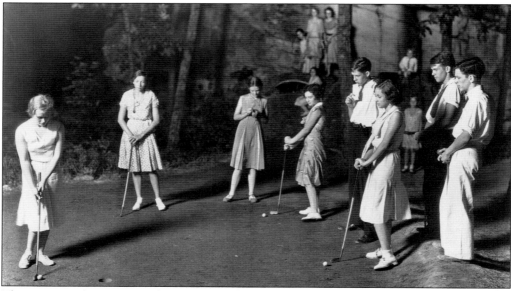

The creation of miniature golf spread rapidly across the countryside, captivating young and old alike. Carter seized on the craze and sponsored a national tournament that garnered attention nation-wide. Baseball slugger Babe Ruth and golfing immortal Bobby Jones came to the mountain mini-course to try their hand. Soon Carter opened a factory on Twenty-eighth Street to manufacture the materials for setting up a course and then turned around and sold the production to a Pittsburgh firm in 1930 at the height of its popularity.

In the 1920s, part of a luxurious life—even for a vacation—included a swimming pool. When many folks in the South went to the old swimming hole, a pool like this one was something to behold. Here a youngster stands high atop a boulder gazing at the cool water that waits below.

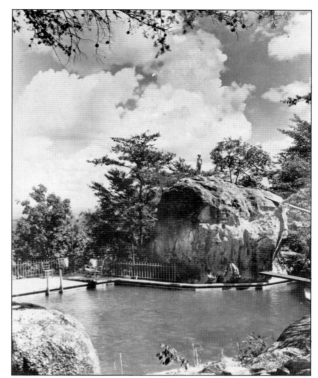

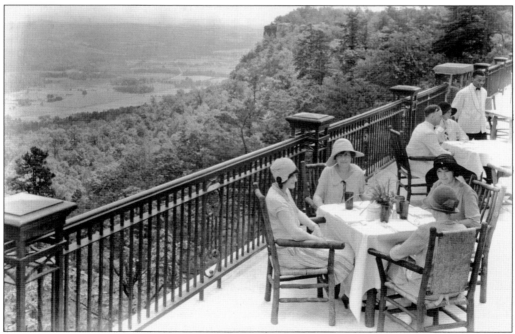

Life was good in the Roaring Twenties especially for the ladies who lunched at the inn. Eating on the East Cliff Terrace in 1926 was quite fashionable, and if the food matched the view, then the occasion was a success.

Lookout Mountain has always been a source of philanthropy and volunteerism. This group of women formed the Lookout Mountain Ladies Chapter during World War I, meaning they were raising money for the war effort and entertaining and supporting the troops that were going to war. Among the ladies identified are Mrs. Sanders on the first row, Mrs. Cahill and Mrs. Linn on the second, and Mrs. Wheelock and Mrs. Giles on the third row.

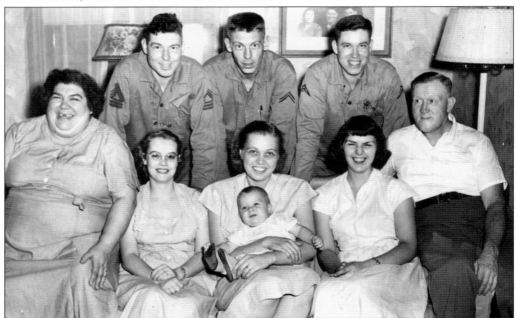

World War II touched everyone and especially families with young men. Pictured here, the Roy Barrows family gathers with their three sons at their home at 213 Watauga Lane on Lookout Mountain. From left to right, the three sons are Sgt. Roy Barrows Jr., Cpl. Charles Barrows, and Cpl. Robert Barrows.

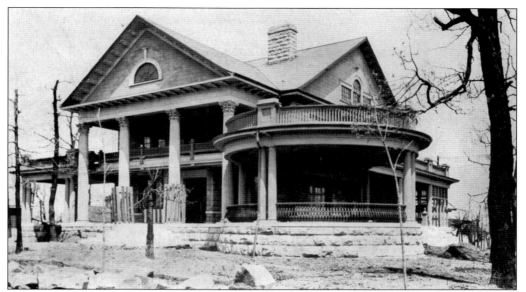

Nothing presents a residential architect an opportunity like a corner lot, and it is evident that the builder of the Giles House is creating a gracious house on the East Brow. David Giles was a successful industrialist and the president of the Chattanooga Foundry and Pipe Works, a huge production facility in downtown Chattanooga. His company was a major force in Chattanooga after the war and rendered him profit enough to construct this fine house of stone in 1906.

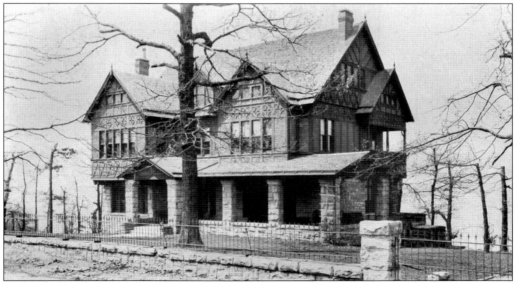

Lookout Mountain's original residences were for the most part summer homes. However, with the building of rail lines up the mountain, it became possible to live on Lookout and work down in the city. The families who purchased lots were wealthy, and their stylish homes were built with indigenous stone and finely crafted. Pictured here is the home of Orion Hurlbut, who served in the first municipal government that was established on the mountain in 1899.

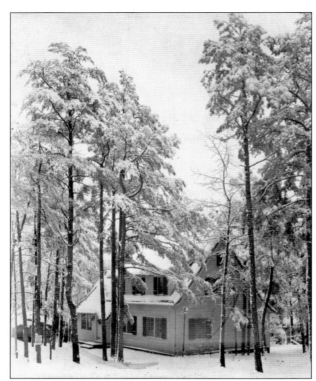

Enjoying the passing seasons on a wooded lot in the mountains is a wonderful thing. Although it does not snow in Chattanooga like it once did, when it does, the upper elevations like the mountains receive more of the white stuff, and it usually sticks around for a while. This house on Hardy Road, a street named after Chattanooga mayor Richard Hardy, sits serenely in the snow amid the tall winter trees.

The bulk of Lookout Mountain lies in Georgia and Alabama; only 3 miles are in Tennessee. In fact, there is a town of Lookout Mountain, Tennessee, and a separate town of Lookout Mountain, Georgia, that are next to each other, each of which has a couple thousand residents. Nonetheless, most of these residents do consider themselves Chattanoogans.

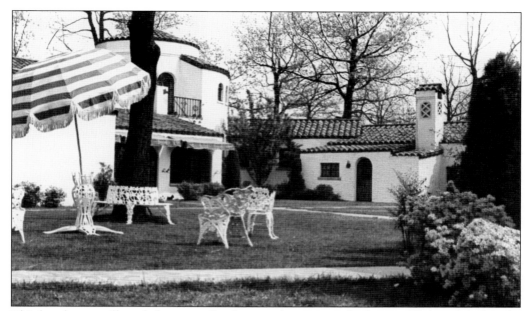

This handsome, villa-style house on Stephenson Avenue was the home of Robert Scholze, the owner of the Scholze Tannery and Southern Saddlery Company, which was situated in south Chattanooga near Lookout Mountain. The tannery operation was another company that prospered after the Civil War in 1873 and was a large part of the town's industrial economic base until folding in 1987.

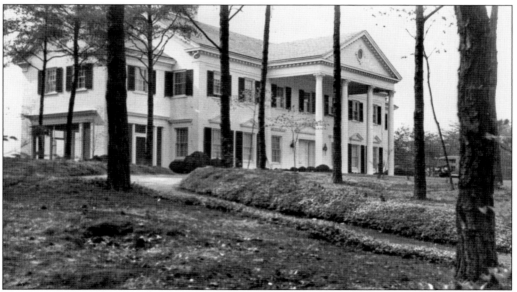

The home of Rudolph B. Davenport Sr. is another example of the fine residential architecture that graces the mountain. The Davenport family became well known for the creation of the Krystal Company, purveyors of the famous Krystal hamburger. Started in 1932 during the depths of the Depression, the restaurant succeeded by offering cleanliness and a good, square, inexpensive hamburger. The Davenports are known locally for their conservation efforts, notably the drive to save Lula Lake.

Zeboim Cartter Patten was a mover and shaker in post–Civil War Chattanooga. Involved in many activities, he is chiefly remembered for founding the Chattanooga Medicine Company. Maker of early products such as Black Draught and Wine of Cardui, the business is located at the foot of the mountain in St. Elmo. Listed on the New York Stock Exchange, it is one of the oldest and ablest companies in the city. Now known as Chattem, it makes a wide range of products such as Icy Hot and the always reliable Kaopectate.

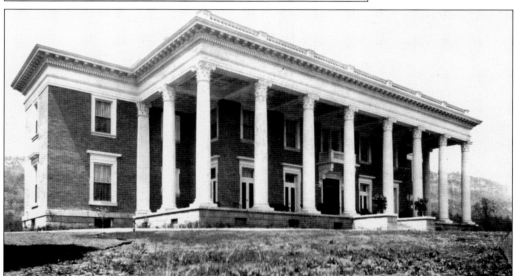

The Chattanooga Medicine Company was successful from its earliest days. With a fleet of salesman who scoured the backwoods and mountain lands of Tennessee and beyond, they made Z. C. Patten a wealthy man. By 1906, he had finished a stately mansion in Chattanooga Valley below Lookout in Flintstone, Georgia, and christened it Ashland Farms.

The Scottish origins of the Presbyterian Church echoed the beliefs of many of the Scotch-Irish settlers that flocked to the Appalachian region in the 18th and 19th centuries. The Lookout Mountain Presbyterian Church located on Bragg Avenue traces its beginnings to an October 1892 meeting at the Natural Bridge. This stone house of worship had its first service on Thanksgiving Day in 1928 and replaced the one that had burned the same year.

The Episcopal Church has long been represented in Tennessee with the diocese centered only 50 miles away on Monteagle Mountain. In Chattanooga, the mother church since before the Civil War has been St. Paul's Episcopal Church on Pine Street. However, the sentiment for a church on Lookout Mountain had existed for quite a while before the Church of the Good Shepherd was founded in 1946. By 1949, the communicants had built this charming parish house.

The age of this log cabin is not known, but it certainly has all the earmarks of an early 20th-century American rural dwelling. At the time this photograph was made, its use was far removed from the trials of backwoods life and instead served a more genteel purpose. It was the meeting place of the Pen Women's Club and was undoubtedly the scene for some refined conversation and more than a few afternoon tea and sandwich gatherings.

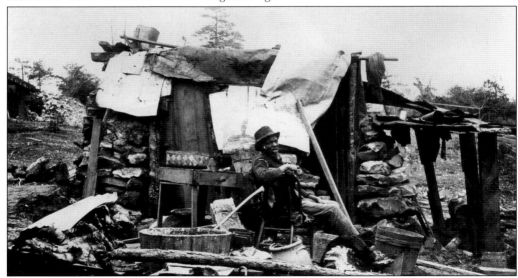

For all its wealth, parts of Lookout Mountain were not prosperous. There was a small African American community on the mountain that was self-sufficient, but for many years, there were a number of people surviving on the side and back of the mountain who were living in tough circumstances. Such a scene is not uncommon in the southern Appalachian mountains. This man seems to have been able to make something of a home for himself from the hard-won resources about him.

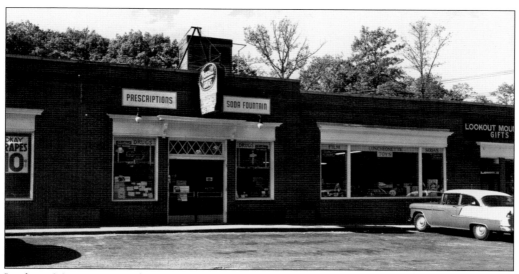

Lookout Mountain was the permanent home of a small number of families by the early 1900s. As the community grew, the zoning of the lots and streets of the community were carefully controlled by the citizens to maintain a residential feel. As such, commercial establishments on the mountain were strictly limited to ones of necessity. One such enterprise, pictured here about 1958, was the Lookout Mountain Pharmacy on the Scenic Highway.

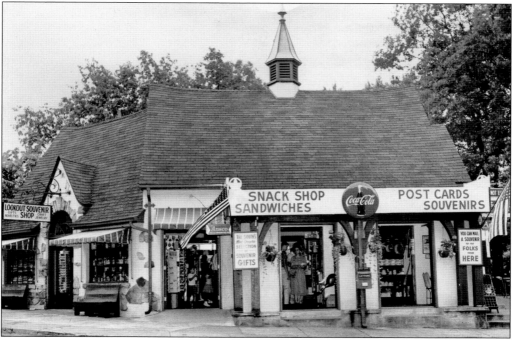

What would a tourist destination be without a souvenir shop? Early estimates of visitors to Lookout before the Civil War were in the thousands a year, and by the 1890s, it was in the tens of thousands annually. This steady stream of generations of visitors was a boon to those selling to the trinket-susceptible traveler, and the mountaintop purveyors of such items have been busy ever since.

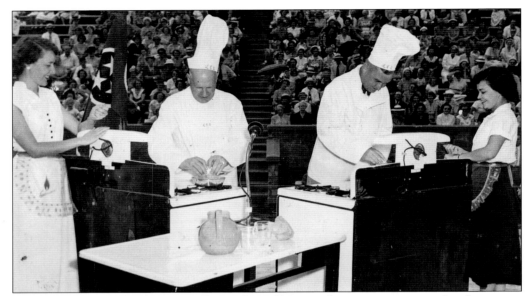

Before electronic technology was offering the public something new every month, advances in making life easier were worth celebrating. Here a local high school stadium is filled with all sorts of folks in ties and hats to watch Mayor Hugh Wasson (second from left) of Chattanooga and Mayor Hardwick Caldwell of Lookout Mountain go head-to-head in a cooking contest on the newest gas stoves. The ladies in waiting are Lillian Roe on the left and Grace Morris to the right.

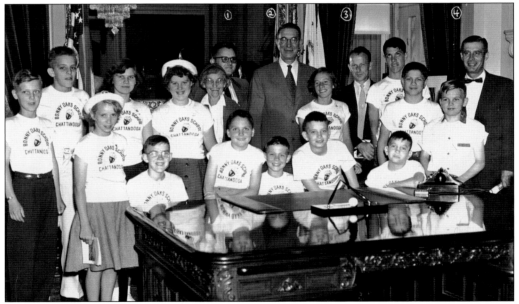

One of Tennessee's most renowned statesmen was Sen. Estes Kefauver (center). Well known for his hearings on organized crime, the Lookout Mountain resident was famous for his trademark coonskin cap. He gained national attention when he ran for vice president of the United States in 1956 on the Democratic ticket. Here in this photograph by F. Clyde Wilkinson, he meets with some Bonny Oaks School students in Vice President Richard Nixon's office in Washington, D.C., in 1954.

110

Eight

TOURIST TOWN

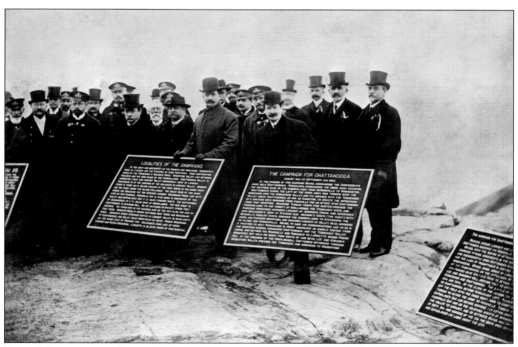

Part of the tourist trade is entertaining famous visitors, so it is rare that a prominent figure would come to Chattanooga without being escorted to the top of Lookout for a view of the grand panorama. Albert William Henry Hohenzollern, or Prince Henry of Prussia as he was known to the world, was no exception. Here he can be seen (first row, third from the left) at Point Lookout with his attendees and a horde of local boosters—such as Newell Sanders, founder of the Chattanooga Plow Company and one-time U.S. senator, and John T. Lupton of Coca-Cola bottling fame—taking in the sights. Next to Prince Henry of Prussia is Dr. Berlin (first row, second from the left), who was a German immigrant. The exact placements of Sanders and Lupton are unclear.

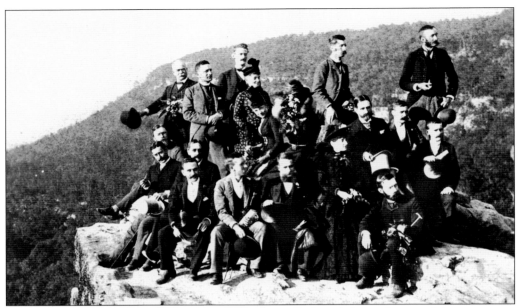

With the movement to establish a National Military Park and the explosion of the newspaper industry after the Civil War, journalists were eager to cover the Chattanooga story. Plenty of ink was spilled on these topics, and these members of the Southern Associated Press were the ones to do it. Of course, the famous newspaperman Adolph S. Ochs was their guide, seen here in the top row, second from the right.

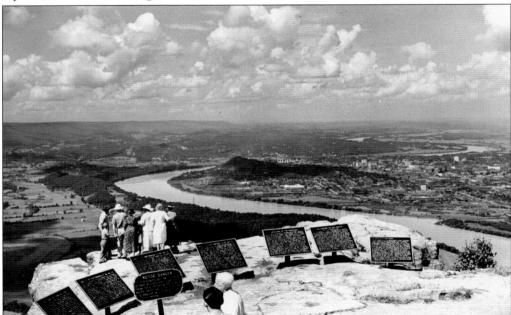

There was a time when some rules were not quite as stringently enforced as they are today. In the 1940s, visitors were quite welcome to walk right past the signs to the side of the cliff. Similarly anyone could sit on Umbrella Rock, but today it is off limits for climbing to the general public. Whether this is due to safety concerns or the fear of litigious lawyers is left up to the viewer.

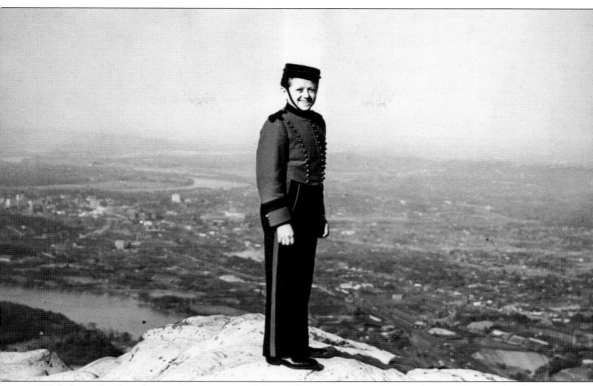

With his usher's jacket and snappy cap, Johnny Roventini was America's most famous bellhop. Only four feet tall, he was known as a "living trademark" for the Philip Morris company. His voice became famous on radio and television for his distinctive call, delivered in a pitch-perfect, B-flat tone.

The Dixie Highway was part of the national movement to connect the nation through a north-south road system. Fortunately it ran right by the river at the foot of Lookout Mountain. Known locally as the Wauhatchie Pike, it was changed to the Cummings Highway in 1931 in honor of Judge Will Cummings and served as a conduit for tens of thousands of visitors to the attractions on the mountain.

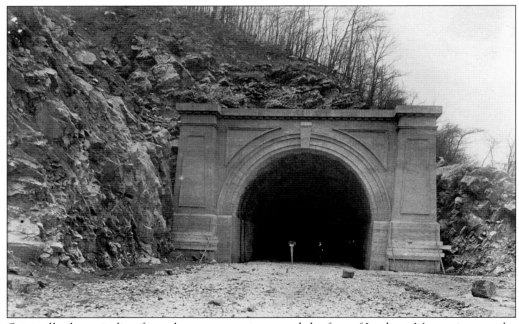

Originally the train line from the west came in around the foot of Lookout Mountain near the river, but it was decided that a tunnel through the mountain was more desirable. Foreign labor was imported by the Nashville, Chattanooga, and St. Louis Railway to carve the 3,500-foot tunnel through the rock, and by 1909, the passage was complete.

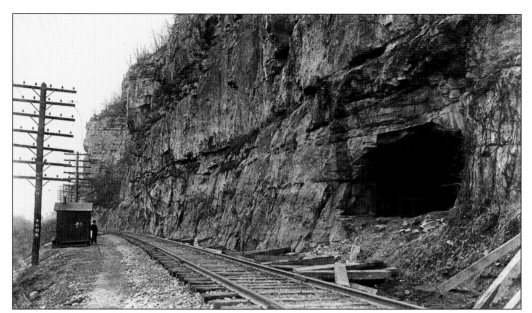

Originally explored by Leo Lambert, the entrance to the Lookout Mountain cave is shown as it looked in 1907. Lambert, who would name the cave for his wife, Ruby, was a serious spelunker. His discovery of the falls deep inside the mountain came after drilling from above, since this entrance was blocked by the railroad tunnel. The falls, with its 145-foot drop, became an instant sensation with the public.

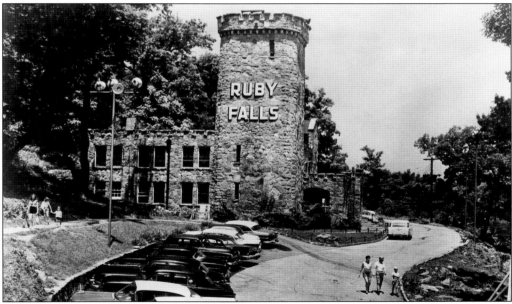

The founders of Ruby Falls built a visitors center to attract drivers to their destination, originally known as Cavern Castle. Constructed of handsome mountain stone and featuring a rounded, viewing tower, the building fits in well with much of the surrounding residential architecture. Omnipresent greeters have stood by the road for years, waving and flagging everyone that comes by and enticing them to inspect the watery wonder that waits below.

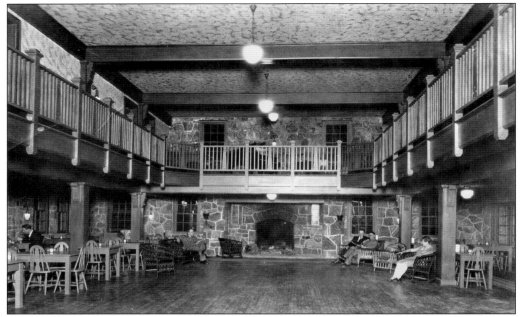

In its early days, Ruby Falls encouraged visitors to come in and relax in this beautiful interior space formed to resemble a great hall in a mountain lodge. The architecture was well conceived and executed. Notice the high ceilings and exposed-beam construction and the windows for light. How different this room would be from the eerie paths below the earth's surface.

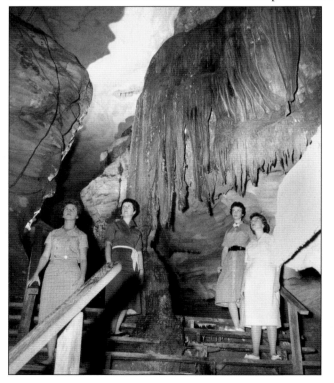

Established as a tourist attraction in 1930, Ruby Falls has endured as a one-of-a-kind attraction for years. Here ladies stop to admire the beauty of the underground cavern as they descend the steps toward the sound of the falls. Beside the rock formations, the winding path and mysteriousness of the mountain interior make for an entertaining and reflective experience.

It is hard to imagine Leo Lambert crawling through the cave 260 feet down when his drilling team first discovered the passage in 1928. They explored the cave and waterfall for 17 hours. Amazingly enough, there is a lower cave 420 feet below the surface that he was trying to reach. The source of the falls still remains a mystery—or a well-kept secret—to this day.

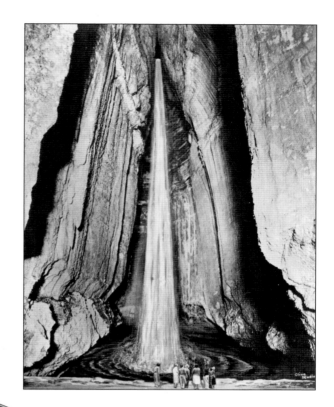

This oval-shaped advertisement for the cave's many wonders shows one of the fascinating formations that may be seen on the underground path to the falls. Not unlike neighboring Rock City, the rock structures are given names such as Elephant's Foot and Steak and Potatoes.

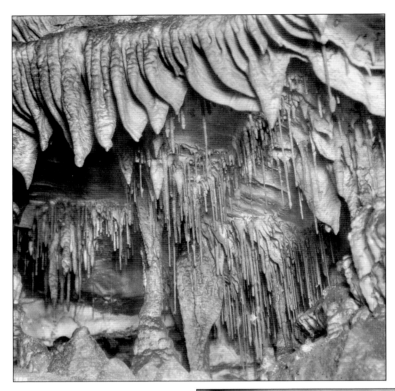

One turn after another on the path brings the viewer to some intriguing places. One such point is known as the Cathedrals and Chimes, named for its obvious reference to church spires and suspended musical chimes. These "natural sculptures" never fail to captivate visitors, especially the young. Other names include Aortic Mirage, Arabian Drapery, and Nativity under the Chandelier.

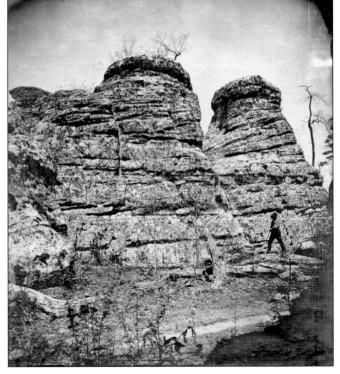

The city of rocks was a magnet for explorers and of course photographers as well. This image from the 1800s depicts a man examining a weathered stack on the mountain. Many of these photographs were published, though a number were used simply as a basis for drawings that would appear in *Harper's Weekly* or *Bryant's Picturesque America* magazine.

Names were important for these stone structures, and this one was no exception. It is easy to see why this formation is entitled Turret Rock since it resembles a gun on a battleship. One would have to believe that this name was given during the war years.

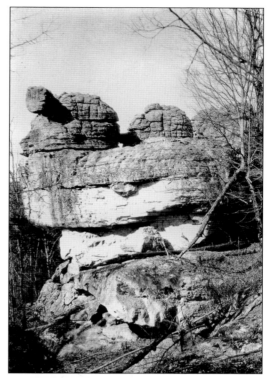

An enterprising young man who dropped out of school, Garnet Carter was an entrepreneur from the start. Always looking for new ideas, he was enthusiastic about his wife, Frieda's, interest in fairy tales and myths and admired her use of gnomes or creatures to liven up the stroll through the compelling rock avenues.

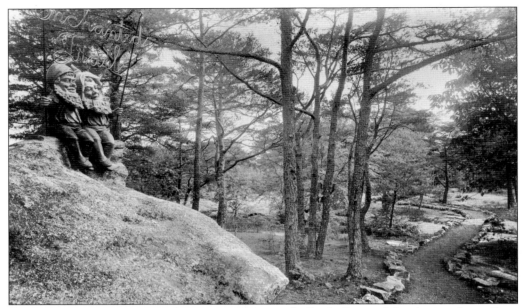

Frieda Carter was instrumental in setting the tone for Rock City and developing the trails as well. The use of German-style gnomes and the hand-lain stonework that flanked the paths gave a fairy tale feeling to the woodland park. Notice the gnomes to the far left. The depiction of different fairy tales, like Little Red Riding Hood or Mother Goose, created a charming feel that appealed to children and adults alike.

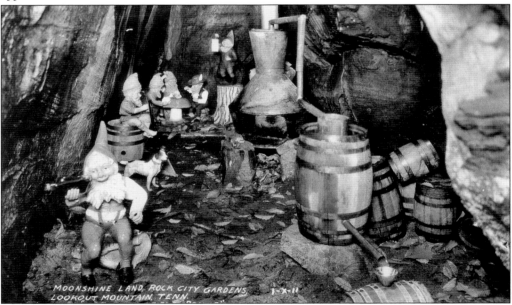

The gnomes were small and often sequestered in overhangs or small "caves" where they could re-create a tableau. Though most were scenes from classic, well-known children's stories, this one differed. Hence, the viewer is presented with an Appalachian scene of moonshiners concocting whiskey. This practice was common in the mountain South and very present on the "back" parts of Lookout Mountain not far from this fanciful reenactment.

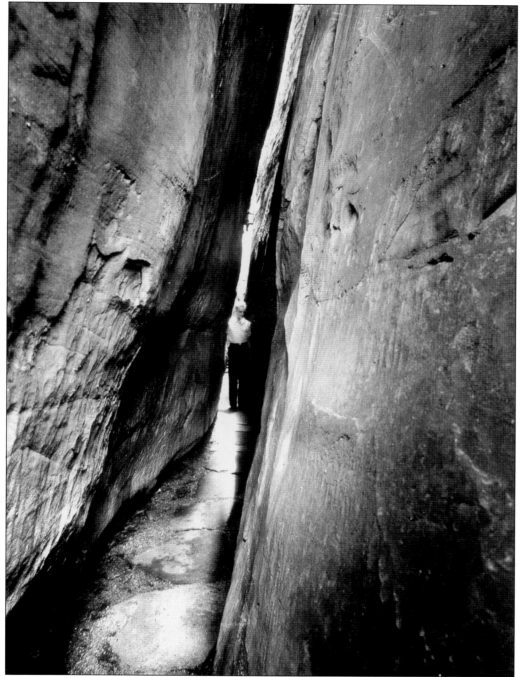

Fat Man's Squeeze is not the name that would most likely be given to this passage today. It is both too critical and gender specific to meet modern politically correct phrasing. However, the name suits the situation perfectly, since the feeling one gets from going through this passage is not so much whether one can get through or not as it is the hope that the rocks do not collapse on the passerby at the wrong moment.

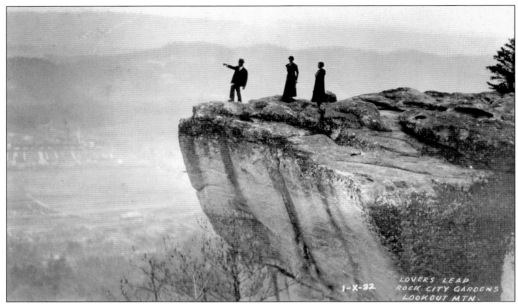

This classic protruding bluff—called Lovers Leap—lets the visitor peer eastward into the Chattanooga Valley and stretches of north Georgia beyond. Though the bluff is supposedly named for a Native American princess who leapt to her death some time long, long ago, the story is suspiciously similar to others around the country, such as the tale of Princess Noccalula in Gadsen, Alabama, on the southern end of Lookout Mountain.

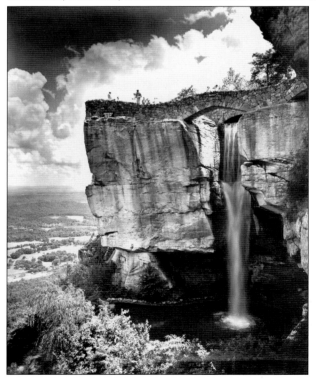

This photograph captures the splendid beauty of how rewarding a clear day on the mountain can be. A waterfall drops below Lovers Leap as tourists meander around the nearby paths. By the 1960s, Rock City had become a standard attraction throughout the South and was drawing 300,000 to 400,000 visitors a year. Today, more than 75 years after its founding, it is broadening its offerings to include weekend musical events to appeal to a new generation and even has a Starbucks coffee shop near the entrance.

Garnet Carter used all sorts of methods to promote Rock City, from small souvenirs to soap, all with the name Rock City inscribed on the product, but one thing that garnered him attention and good business was his clever use of what was then called "outdoor advertising." Billboards were relatively new in the 1920s and somewhat expensive, so Carter simply bartered with farmers to let him paint the name of his business on their roof. With little outdoor advertising, especially in the rural counties, a bold painted sign could make a lasting impression.

The man Carter found who could paint a clear, clean letter that could be read from a distance was Clark Byers. Byers took to the job and began painting around the tristate area of Alabama, Georgia, and Tennessee. A native of Trenton, Georgia, in the shadow of Lookout Mountain, Byers painted mostly with a 4-inch brush and was gifted enough to work freehand.

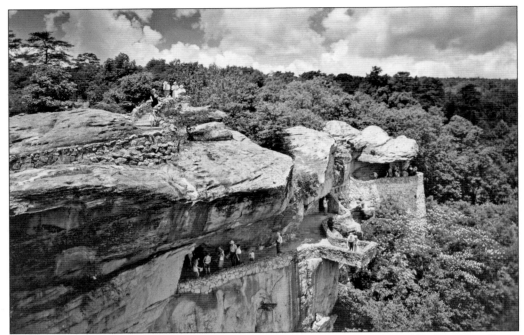

The perfect positioning of the rocks is undeniable. The attraction has created bridges for walking, paths for meandering, and shelters for those wishing to rest and just take in the environment around them. It is no wonder so many families come back year after year.

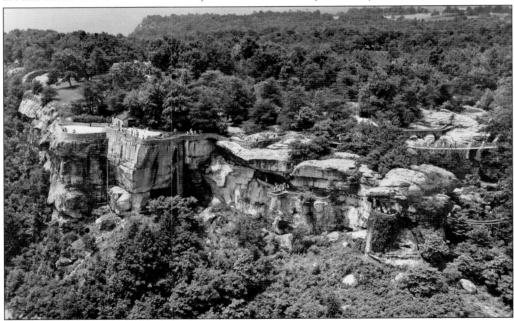

The fabled Rock City is located at the top of the Ochs Highway on the eastern side of the mountain. Consisting of numerous rock formations, both curious and beautiful, the surrounding woods that are visible in the aerial photograph make a barrier around the park and create a small city of stone with a rewarding view of the valley below when the visitor arrives at the edge.

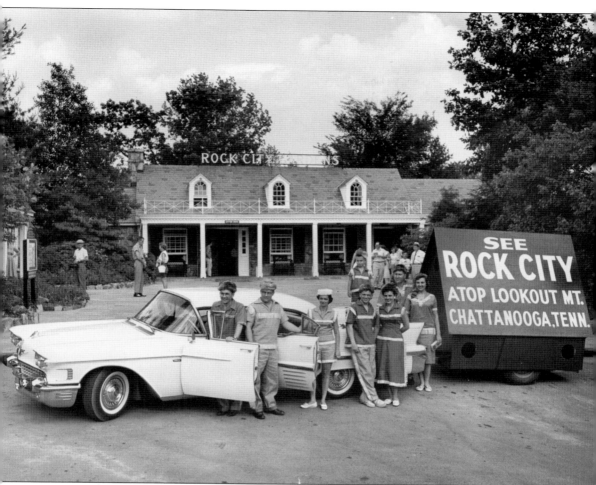

Always the promoter, Carter was constantly trying new angles to advertise his destination. Following the success of the painted barn roofs, he began to sell birdhouses with the name of Rock City on them. Here a smiling group of greeters surround a classic Cadillac that is set to pull a very large birdhouse around town. The coonskin caps that are being worn are a tip-off that this photograph was taken during the Davy Crockett craze that was especially popular in Tennessee, home of the famous frontiersman.

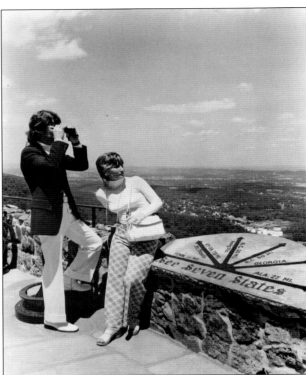

A Europeanesque, mod couple takes in the view through their opera glasses while standing next to the famous "see seven states" sign. Arrows on the horizontal plaque indicate the directions one must look to see the different states, and many people spend a good deal of time squinting at those faraway horizons.

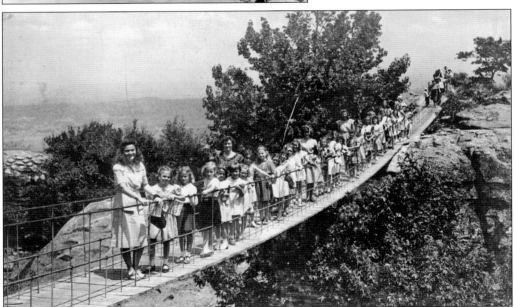

Rock City welcomes all but certainly caters to tour groups and families. Still it literally attracts tourists from all over the world. A surprising number of nationalities can be seen during any given week, and the crowds especially love Christmastime with its holiday lights tour in the brisk evening air. Here a gaggle of Brownie Scouts obediently lines up for a photograph sometime around 1960 during another fun day at the wonderful metropolis of stone.

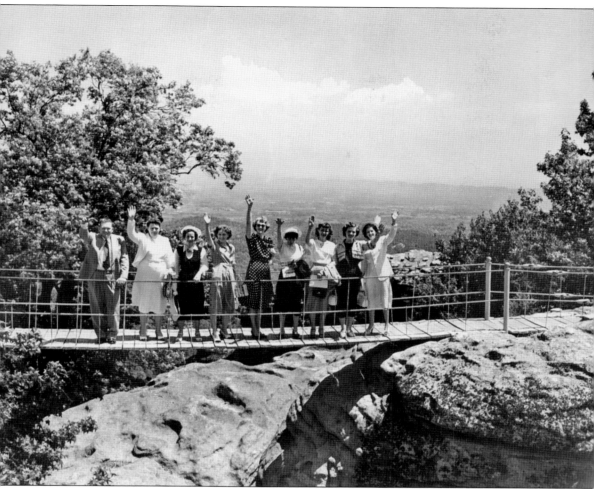

The approach to the edge of the property features a long, swinging bridge known as the "swing-along-bridge." Even with today's sophisticated traveler, the trembling planks and ropes elicit many a squeal and "whoops" and still frighten some people to where they require a helping hand and a gentle coaxing to lead them across the stony abyss below.

www.arcadiapublishing.com

MAP SEARCH

Discover books about the town where you grew up, the cities where your friends and families live, the town where your parents met, or even that retirement spot you've been dreaming about. Our Web site provides history lovers with exclusive deals, advanced notification about new titles, e-mail alerts of author events, and much more.

MADE IN THE USA

Arcadia Publishing, the leading local history publisher in the United States, is committed to making history accessible and meaningful through publishing books that celebrate and preserve the heritage of America's people and places. Consistent with our mission to preserve history on a local level, this book was printed in South Carolina on American-made paper and manufactured entirely in the United States.

This book carries the accredited Forest Stewardship Council (FSC) label and is printed on 100 percent FSC-certified paper. Products carrying the FSC label are independently certified to assure consumers that they come from forests that are managed to meet the social, economic, and ecological needs of present and future generations.

FSC

Mixed Sources
Product group from well-managed forests and other controlled sources

Cert no. SW-COC-001530
www.fsc.org
© 1996 Forest Stewardship Council

Find Your Place in History.